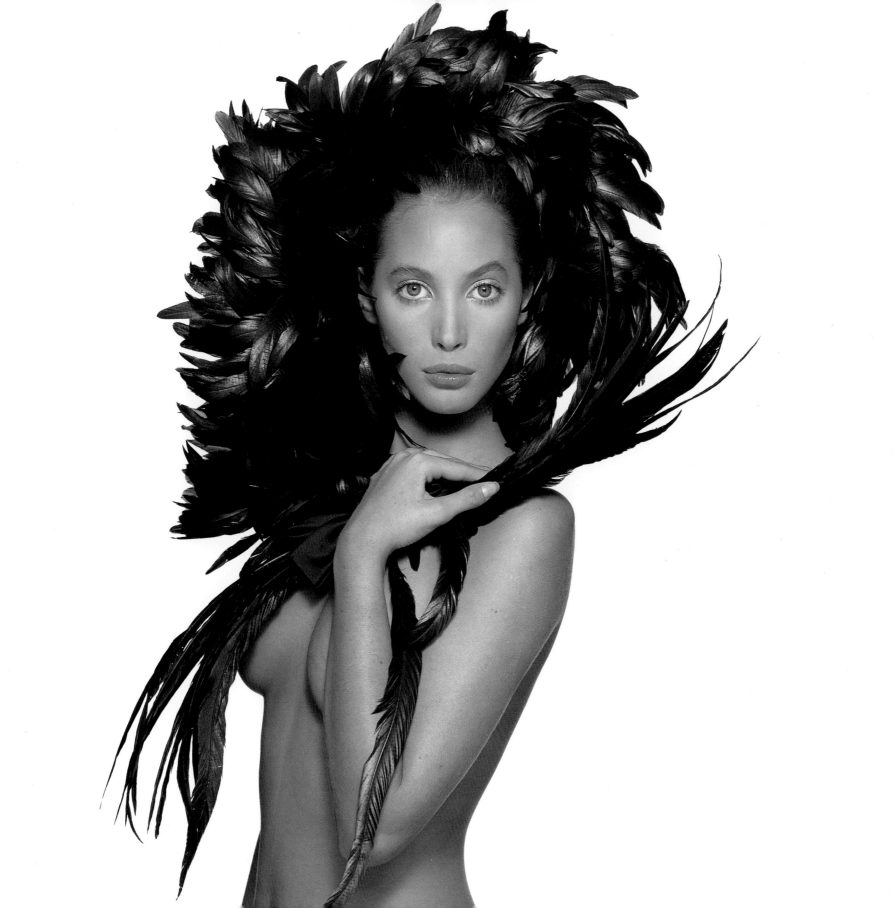

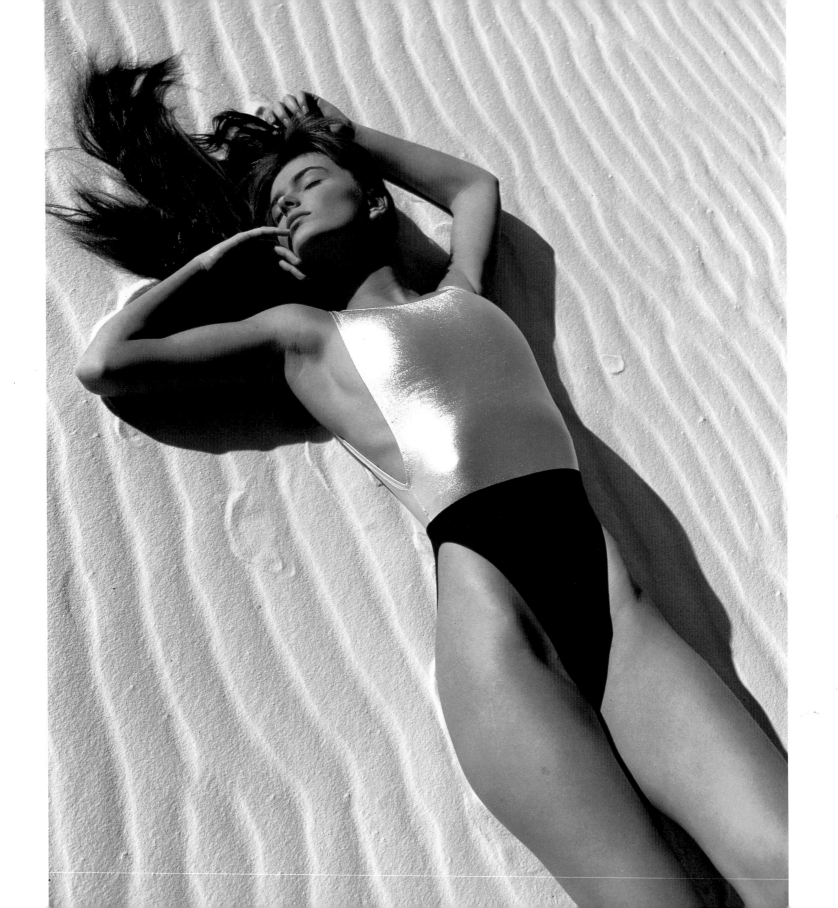

PATRICK DEMARCHELIER

FASHION PHOTOGRAPHY

BY KATHRYN E. LIVINGSTON

INTRODUCTION BY SEAN CALLAHAN

AMERICAN PHOTOGRAPHER MASTER SERIES HENRY HORENSTEIN, EDITOR

A BULFINCH PRESS BOOK LITTLE, BROWN AND COMPANY

BOSTON TORONTO LONDON

A Pond Press Book

First edition

Edited and produced by Henry Horenstein, Pond Press
Designed by DeFrancis Studio, Boston
Production coordinated by Christina M. Holz
Printed and bound by Dai Nippon Printing Company, Ltd.

Library of Congress Cataloging-in-Publication Data
Demarchelier, Patrick.
 Fashion photography.
 (American photographer master series)
 "A New York Graphic Society book."
 1. Fashion photography. 2. Demarchelier, Patrick.
I. Livingston, Kathryn E. II. Title. III. Series.
TR679.D47 1989 770' .92'4 88-12861
ISBN 0-8212-1682-1 (hc) ISBN 0-8212-1736-4 (pb)

Bulfinch Press is a trademark of Little, Brown and Company (Inc.)
Published simultaneously in Canada by Little, Brown & Company (Canada) Limited

Printed in Japan

CONTENTS

INTRODUCTION VIII

PATRICK DEMARCHELIER I

FASHION IN THE EIGHTIES 12

ON LOCATION 50

COVERS 55

ADVERTISING 60

PORTFOLIOS 68

 BOLD NEW LOOK 70

 QUALITY OF LITHE 76

 MOROCCAN REVERIE 82

 BEAUTY AND THE BEACH 86

 SEASCAPES 90

 DANCERS 96

NUDES I02

PORTRAITS I I0

ACKNOWLEDGMENTS I32

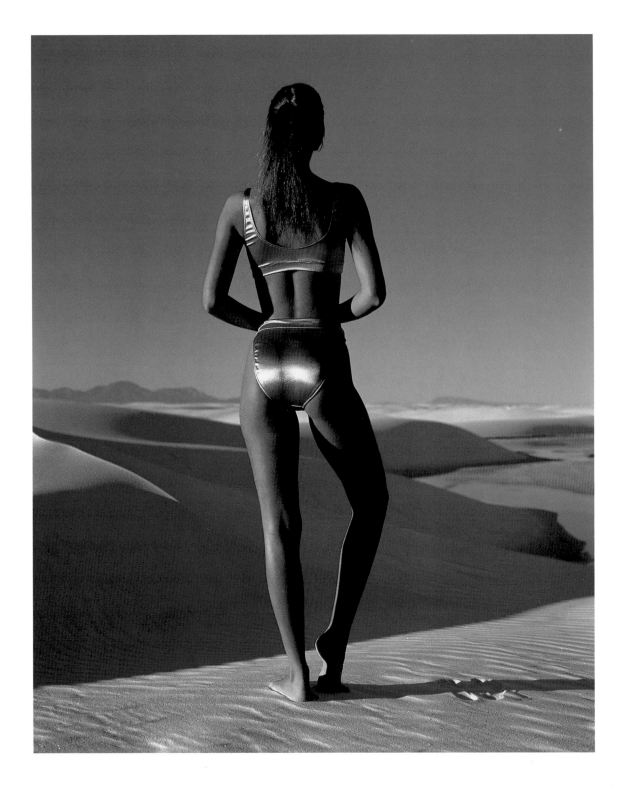

DEDICATED TO MY MOTHER AND MY WIFE, MIA

INTRODUCTION

Late one winter's afternoon, when the light plays strange tricks on us, the term "skating on thin ice" took on new meaning for me. I was making long deliberate strides across a surface that looked like the black plexiglass that still life photographers use. The eerie high-pitched thump of cracking ice, strangely muffled by the water below, alerted me to the rapidly changing ice conditions. The sun was setting, making it difficult to determine whether the ice speeding up beneath me was dark because it was in shadow or because it was so thin that I could see into the deadening void below. What happened next had to do with neither experience nor logic, but rather instinct and dumb luck. Without slowing or breaking stride, something guided me to an area where I *sensed* the ice would be thicker. It was. I was relieved and safe, and, when my heart stopped pounding, some minutes later, a clammy chill sent me home. No more mindless excursions over uncharted regions that day.

Great fashion photographers do a lot of skating on thin ice, but with a measured deliberation and much greater flair than I exhibited that day, five years ago, on Lake Winnepesaukee. The business of fashion photography is based almost entirely on the surface of things. The veneer which these photographers depict is supposed to represent the currently prevailing style or custom in dress and behavior. The weight of judgment as to what is fashionable—and ultimately what is a successful fashion photograph—rests on an improbably thin idea of what (or who) is correct at that moment.

This "rightness" of things is determined by forces largely out of the photographer's control. But the great fashion photographers seem to be untouched by these matters, although not unaware of them. They glide over danger, propelled by a talent for picking the right ingredients: model, clothes, stylist, background, format, and light. They are so sure of their own instinct for what is correct that they are insulated from the ephemeral, silly, and often crass mercantile concerns that drive the merchandising of clothes and beauty products.

Patrick Demarchelier is one of the great solo performers in fashion photography today. Although his images have become familiar to even casual readers of fashion magazines and advertisements, his name is not widely known to those outside the fashion business. For the past decade or so, fashion photography has been dominated by photographers who strove mightily to reinvent the medium. In the process, many critics agree, their excesses nearly destroyed it. In order to get the viewers' attention, these fashion photographers went to great lengths, and introduced elements ranging from homophilia to pedophilia, from androgyny to monotony, and from fascism to fetishism.

Demarchelier is a performer who doesn't let the style of his performance detract from or obscure his photographs. This attitude has proven to be prudent as well as prescient. In an era in which women are expressing themselves more than at any other time, fashion has wisely followed suit with an attitude that British *Vogue* art director John Hind describes as being "looser, where photographers focus on reality, seeing people as you would find them." It is a time in which Demarchelier's fresh, clean, natural look is finally coming to the fore.

It is because of his realistic approach to all aspects of his life and career that Patrick Demarchelier was chosen to represent fashion photography in the *American Photographer Master Series*. His ability to glide over the potential dangers and distractions of fashion makes him an ideal role model for aspiring photographers attracted by the allure of the business. His talent for creating fanciful pictures, rooted in reality, is what makes him successful in today's fashion marketplace. Yet one doesn't have to be a novice looking for inspiration, or a professional looking for information, to admire Demarchelier and his work. If you appreciate an artist who dances confidently and gracefully on the thin ice of the new, then you'll enjoy meeting Patrick Demarchelier.

Sean Callahan
American Photographer, Editor (1978–1988)

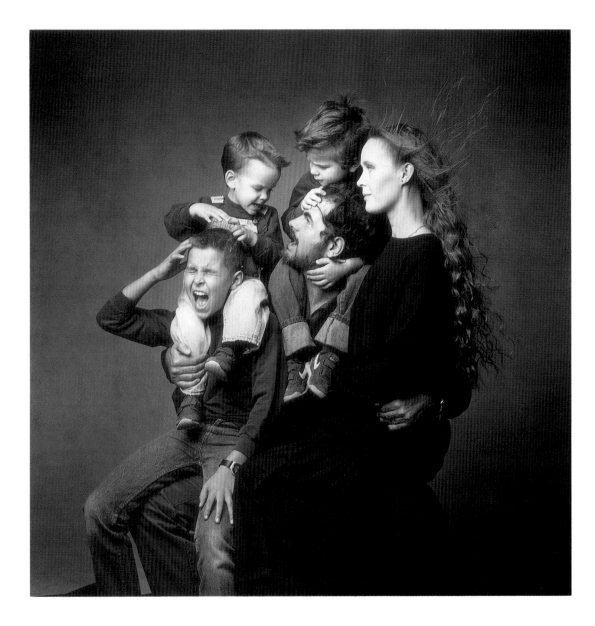

PATRICK DEMARCHELIER WITH HIS FAMILY,
SONS GUSTAF, VICTOR, AND ARTHUR, AND HIS WIFE MIA

PATRICK DEMARCHELIER

Although Patrick Demarchelier is one of the most prolific and dynamic shooters in the fashion world today, he did not set out to become a fashion photographer. Since he came to New York in 1975, Demarchelier has been constantly on the climb, covering the collections in Paris and Milan, regularly shooting for French, British and American *Vogue*, and making dozens of celebrity portraits. For the past decade, he has held a firm and prominent position in a heady and fast-paced world, yet because of the ease and confidence he exudes one might suspect that he rapidly swept to the top of his profession on a chichi Lacroix-designed swing. This—*mais non*—was not exactly the case.

Born in 1944 in a small village near Paris, Demarchelier was raised in the seaside town of Le Havre, third among five brothers. As a child, he was more interested in fishing than in chasing rainbows; he didn't think too seriously about ever becoming an adult, or about what he might possibly do as one. "Patrick had no interest at all in formal education," recalls his older brother Gerald Dearing. "He went through school as if it were constantly in recess."

Demarchelier, who much preferred climbing trees to reading, did not seem headed for occupational success. He seemed more likely to spend his days as a vagabond, nonchalantly exploring the streets and alleys of Paris. But on his seventeenth birthday, his stepfather gave him a Kodak camera. The day Demarchelier had the camera in his hands was the day he knew what he wanted to do. He set out to record his family and friends, and began shooting an occasional portrait. This fascinating pastime steered him away from fraternal revelry and onto a path of his own, and he soon began to consider a career in reportage or portraiture.

At nineteen, Demarchelier landed his first steady photography job in a small lab in northern France. There he learned to print and retouch passport pictures—hardly an

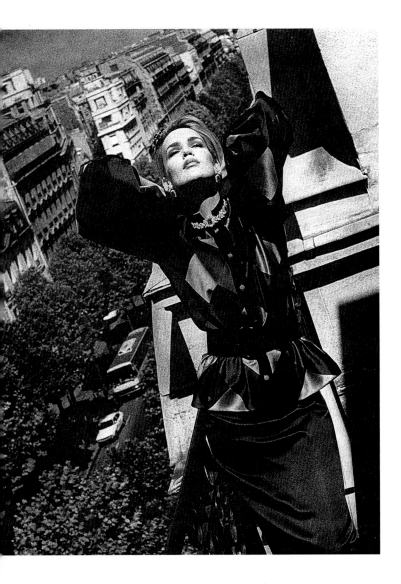

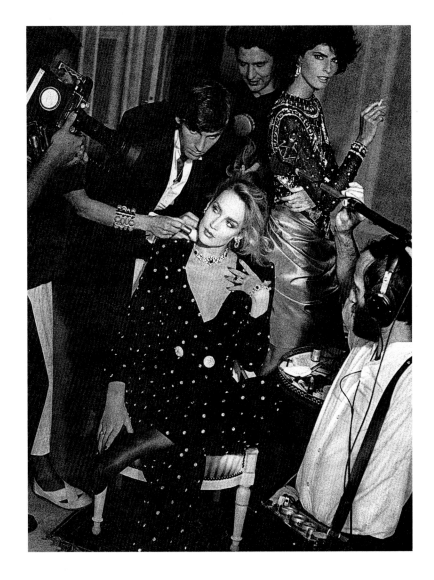

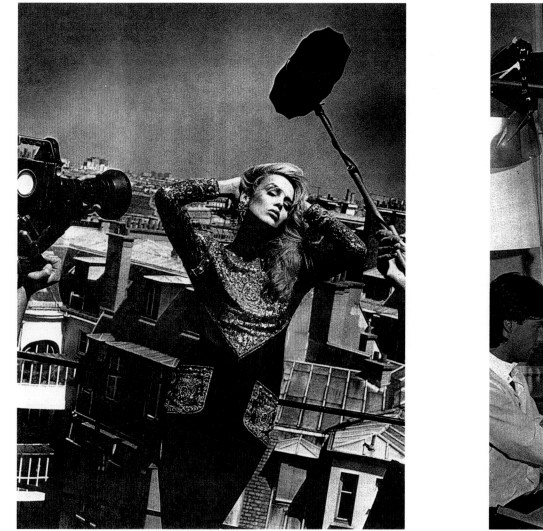

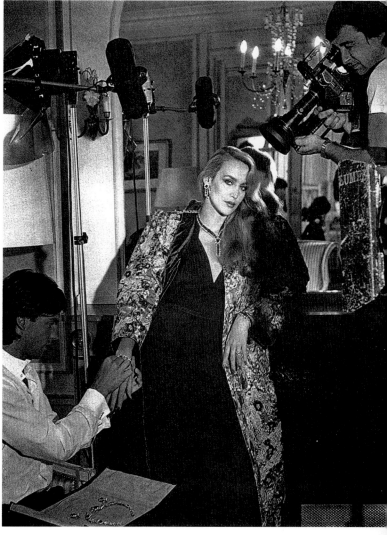

Shooting the Paris collections for Vogue, *Demarchelier was filmed by French television crews. As long as the film crew was around, Demarchelier suggested to model Jerry Hall, why not pretend to be a movie star? Hall enthusiastically agreed, and Demarchelier included the lights, cameras, and action in his fashion series, photographed with a 35mm Nikon camera on the roof of his hotel and in a nearby jewelry shop.*

auspicious beginning. Like many photographers before him, Demarchelier's true entry into the medium began with his discovery of printing. Determined to learn more, he packed his bags for Paris, where he tracked down another lab position, this time printing black-and-white news photos. His job was to produce two or three prints of the same image as quickly as possible. Once hooked on the magic, he wanted to play the sorcerer's part; the next move, he decided, was to become someone's assistant.

A photographer who shot movie magazine covers took him on, and in his spare time Demarchelier sold soap products, pulling in ten dollars a week to add to the twenty he made assisting. When he wasn't working, he was observing the pictures of Frank Horvat, Bill Silano, Jimmy Moore, Hiro, Richard Avedon, Irving Penn, and David Bailey in the pages of *Vogue* and *Harper's Bazaar*. Influenced by the professionalism and drive he sensed in these pictures, if not by one particular style, Demarchelier began to think of striking out on his own. Business was slow at the movie studio, and after six months the photographer could no longer afford an assistant. He thought enough of Demarchelier, however, to hand him a list of potential positions on his way out the door; at the top was the name of a modeling-agency school.

The school hired Demarchelier to photograph the models and produce portfolios for the young ladies. He was also expected to teach the beauties how to pose—a task for which he was completely unqualified. Undaunted, Demarchelier took home a stack of popular fashion magazines and studied the way the leggy models sidled and smiled across the glossy spreads. Back at class, he snapped away, telling the young women when to laugh, pout, or feign demure preoccupation. After a year, he landed another assisting job, this time with the masterful Swiss fashion photographer Hans Feurer, who in the sixties was working as both a photographer and an art director at a Paris advertising agency and was soon to join the prestigious *Vogue* roster.

Feurer knew "far more than I did," Demarchelier admits, but the young Frenchman was not the type to last long in second place. He had already begun visiting various Parisian publications with his portfolio and had received several assignments for *Elle*. At *Elle*, he was particularly good at working with the children's department, and the look of his fashion work today can be traced in part to the fresh, youthful approach he used in this early work. Soon, Demarchelier was working regularly for *Marie Claire*, a French fashion magazine, and some German and Italian magazines, as well as shooting for small advertising accounts. By age twenty-five, his Paris business was booming, but in America—where dreams tend to wander—his name was unknown. The boy who had

Patrick Demarchelier
as a young photographer

loved the frolicsome life had turned out to be an achiever, and Demarchelier set his sights on fashion's Mecca—New York City. The switch to New York was based on intuition—Demarchelier had a feeling that it was the right place to be.

Equipped with a stunning portfolio of fashion pages from *Elle* and *Marie Claire* but with barely a word of English in his vocabulary, Demarchelier arrived in Manhattan in 1975. He settled in a small apartment and studio in Carnegie Hall, and began making the rounds once again. Editors were impressed with his pictures, if not with his communication skills, but told him his work seemed "too European." To this day, Demarchelier is not entirely certain what this meant, but he suspects that his spontaneous, freestyle shooting seemed too unpredictable for the more conservative American press.

With Muhammad Ali

"It was like a jungle at first," says Demarchelier. He sat in his apartment watching television and spent his evenings at night school, studying English. Eventually, work began to trickle in for such magazines as *Glamour* and *Mademoiselle*, and Demarchelier continued to make frequent trips to Paris to shoot for his previously established clients. In a way, having worked in Europe was an advantage; magazines there did not pay as well, and a photographer had to work fast and efficiently to make his mark. Because of less-than-ideal working conditions and a limited amount of cash, Demarchelier learned early to rely on his own resources.

Jeff Rafalaf was graphics director at Clairol when Demarchelier was making his first strides in New York. Demarchelier had been recommended for a shoot, so Rafalaf went to the Carnegie Hall studio, feeling rather nervous since he hadn't worked with the new photographer before and wasn't sure Demarchelier could cut it. The shot called for three models in a finely choreographed cavort. Bearded and slightly disheveled, Demarchelier appeared on the set speaking energetically in an unidentifiable tongue. Rafalaf, becoming increasingly agitated, turned to the stylist and pleaded, "Tell this man that I don't understand French." Nervously, the stylist responded, "But he's speaking *English*."

Other than the catchy refrain, "We make *magique!*" Rafalaf didn't understand a word Demarchelier uttered that day, and when he got back to his office he complained to his associates that he was in serious trouble. But when the pictures arrived they were perfectly executed, conceptually and technically. Twelve years later, Rafalaf (now director of his own sales-promotion company, Ander Communications) maintains, "I still haven't a clue as to what Demarchelier is spouting most of the time, but I suspect he secretly speaks perfect English with a Brooklyn accent because he never fails to

give me precisely what I want." Before long, other art directors and editors who doubted Demarchelier because of his faulty English were put at ease.

John Louise, vice president of creative services at Clairol, recounts a similar tale. Demarchelier appeared on a shoot looking "like a model himself and speaking like a machine gun." But Louise knew Demarchelier's work and had asked Bantry to nail the photographer's shoes to the floor, because each time he called he discovered that the Frenchman was booked in Paris. When the two men finally met to shoot a "summer blonde" ad in mid-December, Louise was not disappointed. Demarchelier created a beach shot in winter by bringing the model up to the roof of his studio and asking her to sit on a ledge. He shot up at the sky, capturing the sun to create the impression of a radiant seaside day in August instead of a grimy midtown afternoon. "He immediately comprehended that he must raise the camera higher to get what I needed, because for beauty shots such as this, it's the hair that counts," Louise says. Demarchelier understood how to put his artistic sensibilities to work for commercial purposes.

In 1979, Demarchelier's work caught the eye of Condé Nast's legendary editorial director, Alexander Liberman. Since then, he has shot regularly for *Vogue*, as well as a number of Condé Nast Publications including *Mademoiselle, Glamour,* British and French *Vogue* and *GQ*. He has also excelled in the realm of celebrity portraiture and his list of subjects, ranging from Kim Basinger to Dustin Hoffman, runs as long as a Wagner libretto. He has shot covers for *Life* and *Newsweek* and toured the world from Montana to Moscow.

Patrick Demarchelier today

In 1981, Demarchelier faced a turning point in his career. He had been asked to shoot a large advertising campaign for a fragrance called Cie, with Candace Bergen as the model. Opportunity often knocks simultaneously at the front and back door, so he was not particularly surprised when, moments later, he received a call from Grace Coddington, then a fashion editor at British *Vogue*. She offered him a major editorial assignment. As logistics would have it, he couldn't do both.

"I sat down and thought about the next few years, and about what I wanted from my career," Demarchelier recalls. "I realized that money was not the important issue— in the long run it would be better for my name to have the chance to work with one of the best fashion editors in the business at one of the best magazines in the world." The credit line was mightier than the greenback, so Demarchelier turned down the advertising gig and set out for London. He has never regretted the decision, which led to a constant flow of British *Vogue* assignments. His experiences while shooting at *Vogue*

and working with Coddington were vital to the progress of his career (and in the end didn't damage his bank account, either).

This kind of success could change a man, but those who know Demarchelier claim that he has the same slightly mischievous manner he had from the start. For a recent self-portrait for a calendar of first-rate photographers, he posed wrapped entirely in gauze like a mummy—an apt visual metaphor for a serious, ambitious man who seems evenhandedly glazed with humor.

"My brother is a very wise man—as they say in France, he is as wise as the peasants," says Gerald Dearing, now a movie producer. There has always been a surety and a sense of harmony in Demarchelier's life. "His decisions come naturally and are never intellectualized. He doesn't take himself too seriously, and yet he is always very professional." Dearing attributes his brother's attitude toward his profession, in part, to the nature of his route to the top. He worked whatever jobs he could, and unlike many fashion photographers who take a good assisting job and then strike out for quick and often short-lived success, Demarchelier has made undramatic but steady progress.

Although the forty-four-year-old Demarchelier is easygoing, he possesses a strong quality of authority. When he talks, people listen—even if they can't always understand him. He has a short salt-and-pepper beard (heavy on the pepper), long cherubic tresses, a beguiling grin, and a firm handshake. His studio, a spacious rectangle in Manhattan's fashion district just off Seventh Avenue, matches his personal style. The slipcovered red couch in the waiting area is comfortable but lumpy; the *salle de bains* is, well, on the rustic side. A scratched wooden table in the reception area is dotted with red "fragile" stamp marks. Red metal chairs and an old ping-pong table invariably covered with boxes of shoes and scores of baubles and belts are the only furnishings, other than the framed magazine covers that line the walls.

A muscular young man listening to hard rock in the elevator drops messengers, art directors, editors, and a constant parade of models—from undiscovered hopefuls to Brooke Shields—at Demarchelier's door. There, one is greeted by Wayne Takenaka, Demarchelier's soft-spoken and diligent studio manager, who may ask if the visitor requires a glass of orange juice, to find that the refrigerator is loaded only with film. A blonde, barefoot makeup artist playfully wrestles with Demarchelier on the floor for the latest issue of *Vogue;* this year's hot model Paulina Porizkova sits at a mirror, langorously smoking a cigarette. The door buzzer crackles and phones ring incessantly (if the studio's closed, *c'est la vie;* there's no answering machine). The atmosphere is

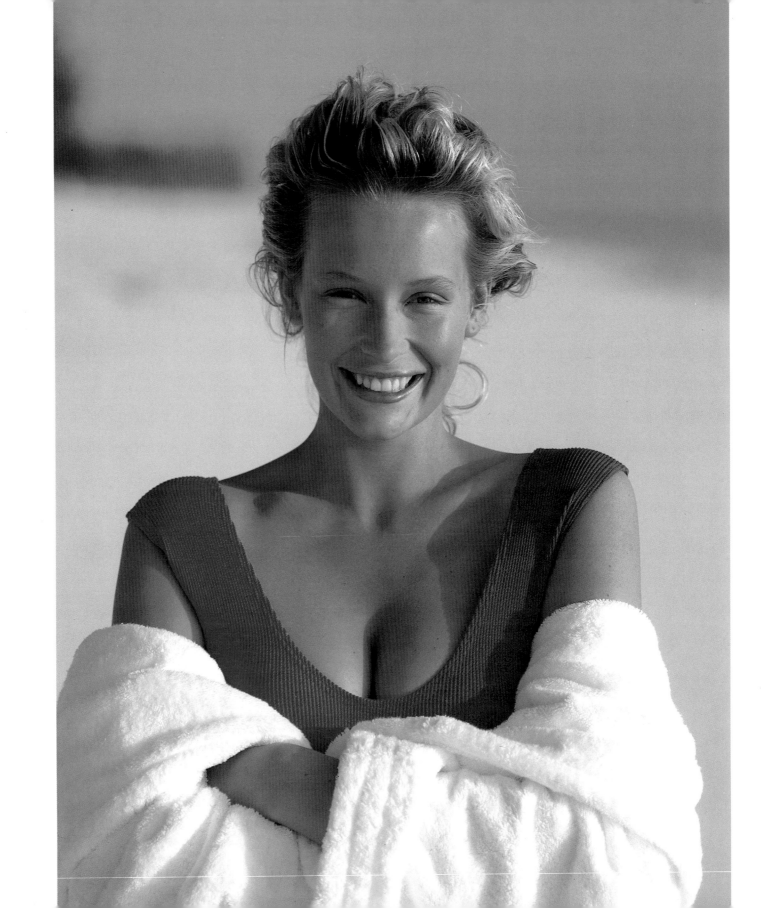

decidedly casual; the unspoken message, in case we were wondering, is that here, at least, even the glamorous life is real.

The father of three young sons and the husband of former model Marie Christine, Demarchelier is a family-oriented man who reserves nearly all weekends for his wife, children, and close friends. He enjoys skiing, windsurfing, sailing and other outdoor sports, and firmly believes that a well-cultivated private life is essential to his occupational success. He maintains that the energy he expends during the day can best be replenished during time being a father and husband. On a typical Friday afternoon in the Demarchelier digs, it would not be surprising to find ten-year-old son Gustav skateboarding through the studio, munching pizza. Babies or small dogs arriving in the company of svelte young men and women are welcomed as hospitably as the models themselves. Clearly, Demarchelier has not been inflated by success; he finds that the real pleasures in life come from a long afternoon at the ocean or sharing lunch with his sons.

This carefree personal style is reflected in the photographs that have made Demarchelier's name one of the most frequently and affectionately repeated by editors and models on the international fashion scene. His images possess a breezy, understated elegance and convey a thoughtful, realistic outlook. Like many Frenchmen, Demarchelier loves the good life, and he imbues his work with his own strong sense of assurance and satisfaction.

It is not so odd, therefore, that the small boy who'd rather swim than study became a man who seeks simple pleasures—who takes a break in a sporty fashion sequence to windsurf with the models, or halts a shoot with Paulina Porizkova because the sushi is getting dry. With his unmannered, unhurried style, Demarchelier breathes real life into the fashion world, which has often been criticized for self-absorption and superficiality— into a world that, to paraphrase Oscar Wilde, must change every six months because of its ugliness. Demarchelier's photographic vision and way of working reflect the way a select group of excellent designers, art directors, and editors are approaching contemporary fashion—with their backs turned to artifice and an eye toward the authenticity of human emotions and pleasures. Life and fashion are by no means a joke to Patrick Demarchelier, but each is to be savored, and ultimately enjoyed.

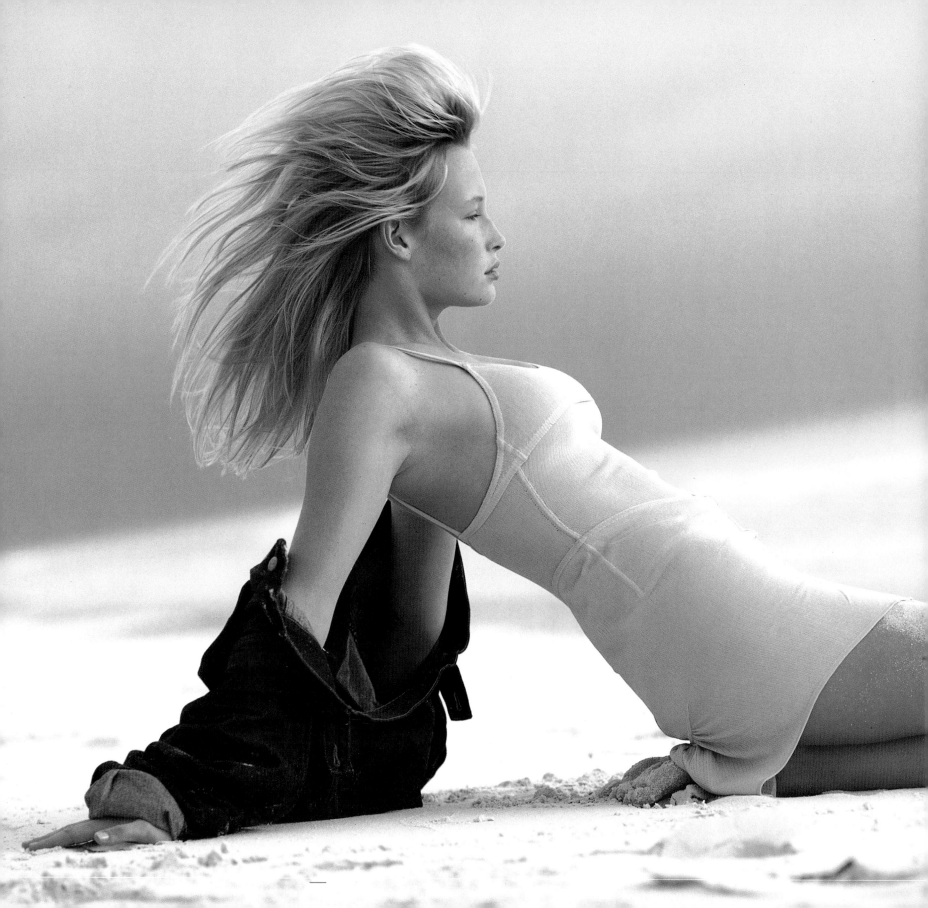

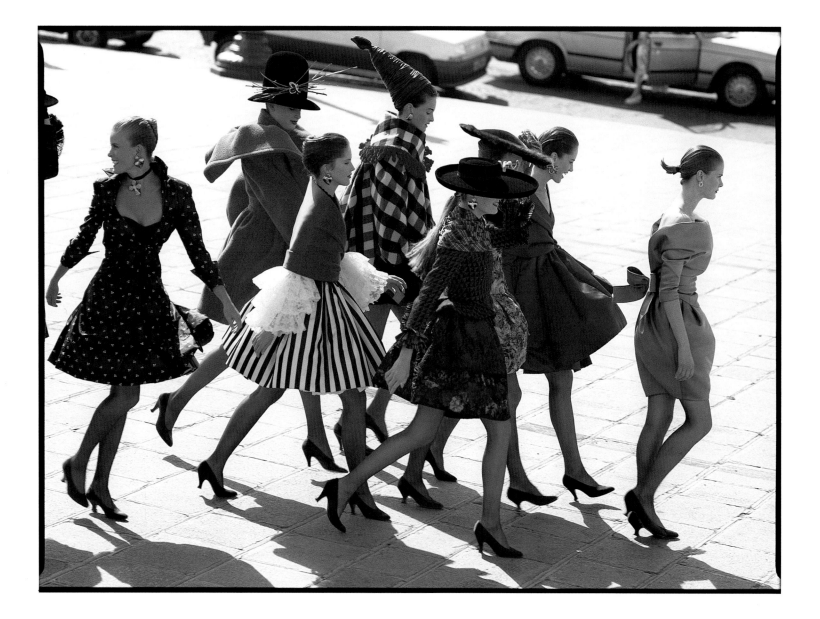

FASHION IN THE EIGHTIES

In the 1930s, when the Hungarian photojournalist Martin Munkacsi took his camera outside to shoot women in motion for *Harper's Bazaar*, fashion photographers everywhere began escaping from their shackles. Until that time, 8×10 cameras and a studio location were *de rigueur*. In the forties, Toni Frissell had captured bobby-socked women on bikes; silk, nylon and rayon were more likely to be found in parachutes than on the girls back home; and Cecil Beaton traded his salon backdrops for bombed-out buildings. By the fifties, women were smoking cigarettes in pictures (albeit with elegant holders) on their way to the revolutionary sixties when they would bare their breasts, backs, and even their well-groomed toes.

By the seventies, fashion photography had rounded a disturbing corner. "Anything goes" seems to have been the motto, and in Europe, at least, just about everything went. In the seventies, as Nancy Hall Duncan points out in her book *The History of Fashion Photography*, Helmut Newton and Guy Bourdin were given complete creative autonomy at French *Vogue*. Fashion images began to explore homosexuality, transvestism, voyeurism, and rape. This, Hall Duncan notes, prompted critic Hilton Kramer to write that "fashion photography as we know it is over, replaced by murder, terror, and violence as viable subjects." Bourdin's image of the outline of a woman's body chalked on a sidewalk near a car, or Chris von Wagenheim's vision of a lovely seductress embraced by the fangs of a doberman, were about as far as one could conceivably get from the diaphanous turn-of-the-century beauties of the first fashion photographer, Baron Adolphe de Meyer.

The eighties have shown that fashion photography is not over at all, and like the men and women it depicts, fashion imagery has been given a new and possibly more wholesome life. "There is much more freedom in fashion photography today and everything is much more honest and real," says Polly Mellen, U.S. *Vogue* fashion editor.

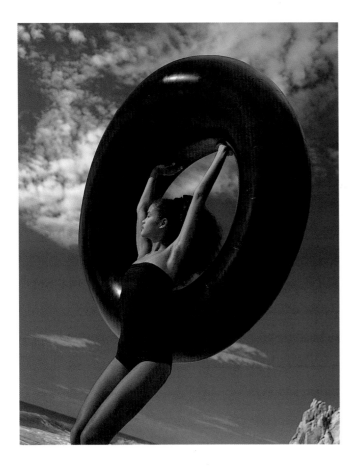

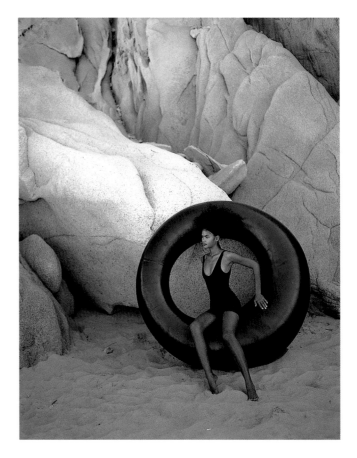

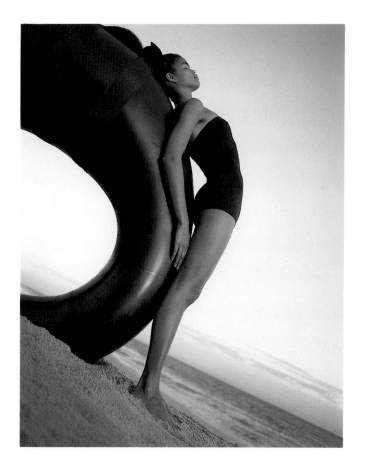
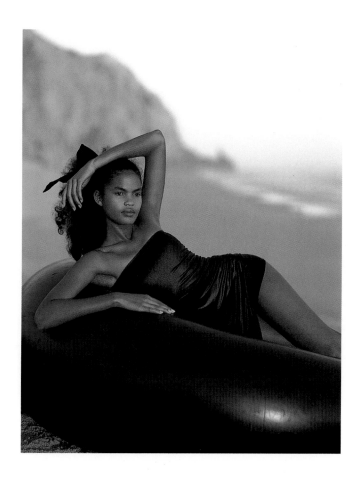

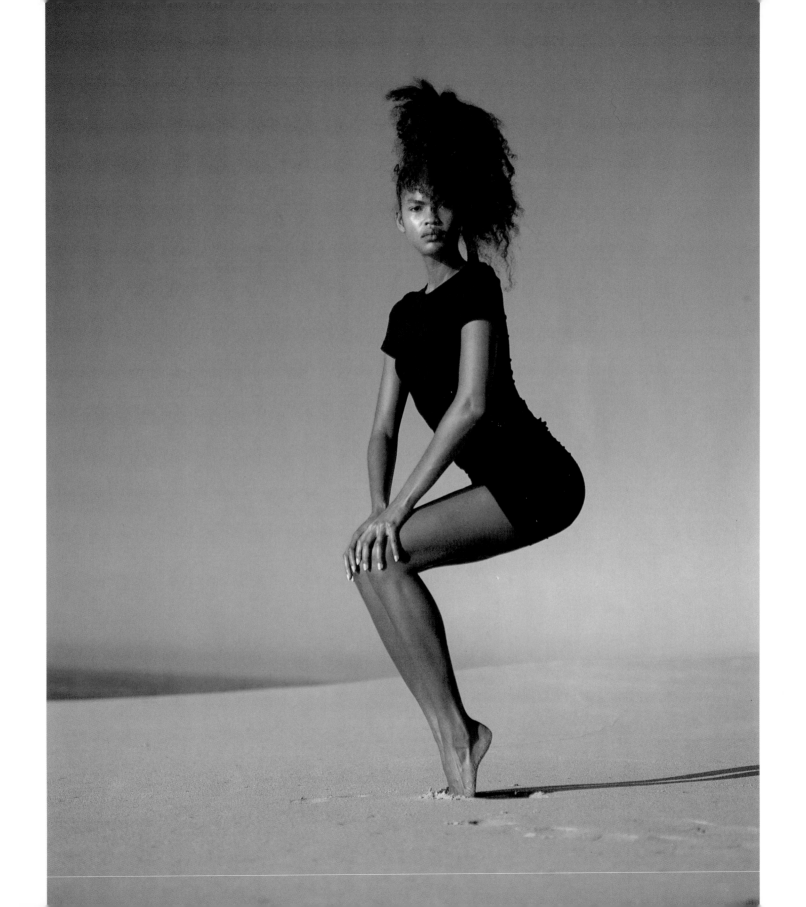

"Many more pictures in the eighties are made with the young woman caught off guard—we are peeking into a private moment. Life is carefree, messier, a little unruly; everything is not just perfect. But the woman fashion portrays in the eighties is not afraid to show she is worried about herself—she's a more grown-up and thoughtful person."

The continuing progress women have made in their professional and personal lives has been reflected in their clothing; though haute couture is still alive and elitist, ready-to-wear runs the show. Styles have become functional yet free-spirited, and designers are showing the knee for the first time since the sixties. The trend toward masculinity—ties, suitcoats, and short hair—has been replaced by a more feminine look. Although fitness and a firm, healthy body are important, contemporary women realize they can look trim and still look female; breasts, at last and once again, are as desirable as biceps.

Elizabeth Tilberis, editor of British *Vogue*, points out that fashion and fashion magazines have become "sexier than ever." Men have joined women on their pages, no longer the stilted puppets of George Hoyningen-Huene's day. Men and women are viewed together in romantic and erotic moments; fashion's intimate universe is no longer for women only. In the work of Bruce Weber, who has vastly changed the way we perceive men in pictures, we see men who have traded their conventional austere manner for passion. No longer suited frames lurking in the background, men are seen dancing, racing, swimming, laughing, and in various stages of dishevelment. As women have eased down from their pedestals, the fashionable men of this decade have been freed to embrace them.

Fashion doesn't change overnight—women don't struggle into girdles one day and go braless the next, nor do men in tuxedos reveal the contour of their multi-colored jockeys. The evolution is gradual but steady. A photographer must be ready and willing to adapt to keep up with the progress of fashion while maintaining an individual style and recognizable way of seeing. "You must move with the evolution of fashion, go with it or before it, but don't let yourself be left behind," Patrick Demarchelier cautions. In the past, he says, fashion photographs were somewhat stilted, and their creators possessed strong, impregnable styles. Today, though a secure artistic vision is desirable, an unyielding approach will trip up a photographer's march toward the future. "You have to be able to adjust the way you work, to move freely between casualness and elegance. Otherwise, what will happen to you when fashion moves the other way?"

The life of a fashion page is ephemeral, and only a handful of photographers possess the qualities necessary to make lasting images. Nevertheless, in the flurry of changing

styles and faces, some photographs manage to stand out. What made Horst P. Horst's 1939 picture of a woman modeling a corset an emblem of a decade, or Irving Penn's "Twelve Beauties" an immortal icon of a golden era? Why were Arthur Elgort's picture of a windblown Lisa Taylor and Helmut Newton's seductive photo of the same model eyeing a man signposts of the seventies? Some fashion photographs have *the* look—a carefully measured mix of the model, the clothes, the mood, and the photographer's personal signature. In these images, the essential elements of lighting, atmosphere, composition, and style combine to reflect the spirit of the time and the spirit of the artist. "To make an image come up off the page; to stop the eye and shock the memory" is one of Demarchelier's consuming passions. Making a fashion image that will last is one of the most challenging aspects of fashion photography.

Alexander Liberman calls Demarchelier a "gentle pioneer." In the eighties, he observes, fluidity and charm entered fashion, and a photographer had to be ready to respond rather than impose a rigid look. Fashion encouraged every woman to express her unique personality, and Demarchelier, Liberman believes, was one of the first to catch this naturalness. Like paparazzi, fashion photographers tracked the clues of change, and magazine editors, having learned from the impact of film and television, realized that the still camera had to seize not only the decisive moment, but the decisive *movement* as well. Fashion has become softer and more accessible, and photographers like Demarchelier and his countryman and friend Alex Chatelain are part of what Liberman calls the "French invasion" of men who have a "sensitivity to the natural attractiveness of women" and who can capture their personal dimensions along with their physical traits.

In the eighties, what had been known as the European look began to meld with an American sensibility. As fashion evolved, the traditional delineation between the posier American and unrestricted European styles became less sharp. American photography, once "polished and plastic," became more free-styled, says Grace Coddington, now design director at Calvin Klein. The fashion world, as Liberman sees it, became accordingly less insular, and a healthy exchange began. Models today travel more; American photographers shoot in Europe and European photographers haunt Manhattan. Even the refreshments served at shoots have become more cosmopolitan, points out hairstylist Didier Malige. Location work has also changed; in the past, a trip to Mexico might mean shooting models poised by ancient temples. Today, Demarchelier says, "you go to Mexico for the sun, the light, and the mood—you don't really know from

the picture where you are." As Polly Mellen says, "Demarchelier has an extraordinary way of placing the models into the ambience of the location. He uses the light and air of the outdoors, creating an atmosphere in which we may not be conscious of anything more than the skyline and the energy of the place."

The exaggerated look of the seventies has been replaced by a trend toward naturalism. "Things have become looser, and fashion and fashion photography have begun to focus on reality, seeing people as you would find them," says John Hind, art director of British *Vogue*. Demarchelier cuts through the inherent artifice of fashion work to capture a more spontaneous feeling. The photographer says simply, "I like real laughter in my pictures."

Fashion and fashion photography have not become mundane or ordinary, but the line between glamour and believability is more skillfully drawn. There is still a place for romanticism, eroticism, fantasy—even for Helmut Newton—and for the reveries of Sheila Metzner and Sarah Moon or the fashion "stories" of Deborah Turbeville. But Demarchelier's "sense of reality," as former art director at *GQ*, Mary Shanahan, now at French *Vogue*, calls it, plays a key part in contemporary fashion photography. Wherever their fantasies may wander, men and women of the eighties have their feet firmly planted on the ground.

However, fashion photography does not reflect the "real world," something Demarchelier is quick to confirm. Fashion photography creates an undeniably contrived universe meant to make a woman or man purchase the clothes, perfume, or accessories exhibited. But for a fashion image to work in a way that reaches beyond a simple catalog product shot, it must possess a sense of atmosphere and somehow suggest that an ideal lies beyond the prosaic and wearable aspects of a product. The best fashion photographs exude an innovative imagination, but are also composed of believable possibilities.

Buffy Birrittella, vice president of advertising at Ralph Lauren, notes that fashion may change in hundreds of ways—the shape of a shoulder, the length of a skirt, the width of a lapel—but fashion in the eighties has evolved gradually out of the past decade's progress. The woman of the eighties has a forthright character and personality, and it was Demarchelier's interpretation of not only the softness and romance of women but of their intelligence and resolve that attracted Lauren to his work (when he saw Demarchelier's pictures of his wife Marie Christine in a European publication in the seventies). Lauren fashions, Birrittella notes, appeal to the way the modern woman has developed in the past decade, "to the way she lives and what she's really about." The

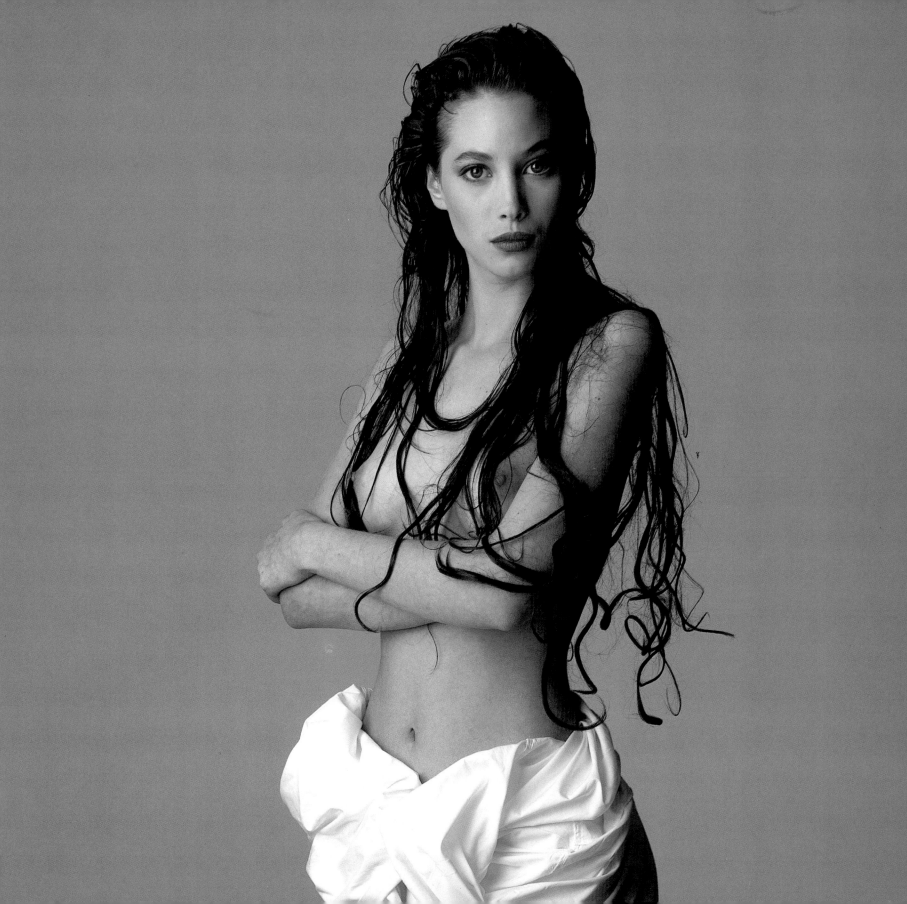

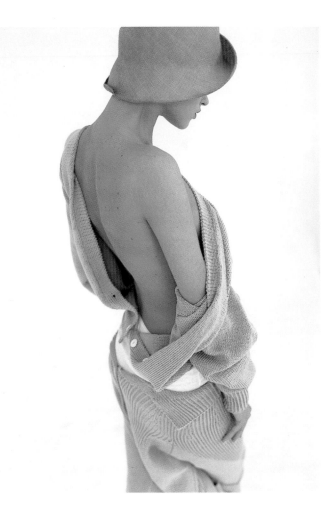

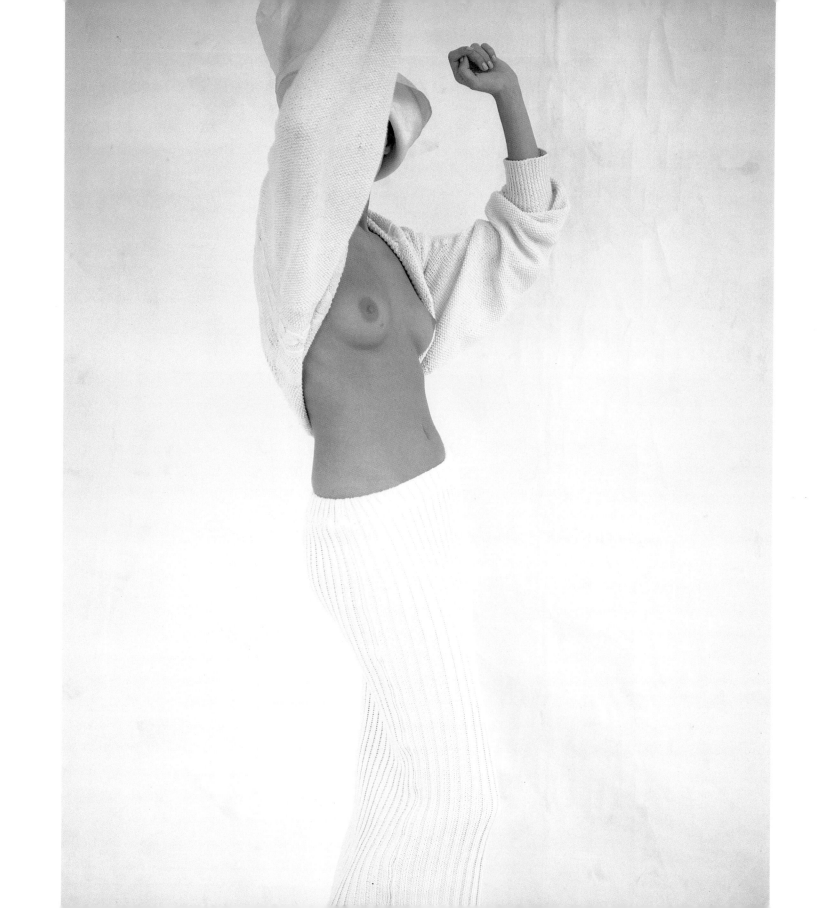

eighties woman is many different things at once, and it's her backbone as well as her femininity that Lauren's campaigns seek to capture. "She's not overwhelmed by the clothes, and isn't driven by fashion. She has an involved, intelligent life which includes work, friends, family and home . . . she's not a 'fashion person.' "

For "people pictures," Lauren uses primarily Bruce Weber and Demarchelier. Weber's successful advertising campaigns for Ralph Lauren, says Birrittella, create movies about whole lives, with casts of characters playing roles. In this way, as Liberman has said, today's fashion photography borrows from film, revealing not only a still moment but a continuum that describes our changing world, of which fashion is only a small part. "Fashion photography will continue to grow with that character," Birrittella predicts, "but it is much to ask from one photographer to capture such a variety of ideas in a single image." Due to the influence of film and the desire to reveal many facets of men and women's lives, we increasingly see fashion advertisements that run for as many as a dozen pages, with the same models in various styles and situations. The sequencing and juxtapositions that make editorial fashion images so fascinating have spilled over onto advertising space. Styles and products are no longer presented in a static manner, but seem to be increasingly incorporated into the design of life.

Demarchelier's personal reflections on fashion fit well with the fashions of our time. He doesn't care much about the styles that hang in his own closet; he's likely to turn up in a wrinkled shirt with a hole in the sleeve or to wear socks that don't properly match. "People should dress the way they feel, not trying to look fashionable," he says. Individuality is the guiding force behind fashion as it heads toward the nineties. Red may be in one season and black the next, spiked heels may be kicked out by flats, yet there is no uniform other than dressing to match the times and one's inclinations.

Nevertheless, Demarchelier studies the clothes he photographs. He has particular favorites—sportswear and elegant clothing intrigue him; everyday streetwear he finds a bit dull. As a fashion photographer he can look at a design and know how it should be seen, although the clothes themselves are not his primary focus. "Women in the eighties want their clothes to work for them, and Demarchelier understands fashion," says Tony DeVino, vice president of product presentation at McCall's Patterns (who has worked with Demarchelier on a pattern book featuring Brooke Shields). "He knows how to capture the way the body moves and curves within a certain dress."

"I make an *image*," says Demarchelier; the clothes fall naturally into place. His attitude is neither flippant nor careless, but he seems to religiously believe in the sanctity

of mystery. To plan or explain too much, apparently, is to Demarchelier an insult to the sacrosanct nature of his work. To reveal too much spoils the fantasy and infringes on the power of the dream.

Fashions, models, and the mood of a particular time constantly evolve and change, but one aspect of a fashion photographer's work must remain consistent—quality. "You're only as good as your last set of pictures," says photographer David Bailey, who blew in via London with the beat of the sixties and has kept a hot rhythm ever since. Similarly, Demarchelier says, "Nothing is ever certain—you can be the best in the world and not be sure if you will be working next year." This aspect of fashion photography is not unique to the medium; a surgeon won't be asked back to the operating room if he misses the proper incision, nor will an audience overlook a clarinetist's struggle with the unwieldy opening cadenza of "Rhapsody in Blue." Yet photographs, unlike musical notes, linger before the eye, giving critics and viewers ample opportunity to decide if the image and its creator are worth remembering.

"The fashion photographer is hired for his pictures, not for himself, and each time— every day—he has to do his best again," Demarchelier explains. Some clients may be more patient than others, but with many thousands of dollars and precious time resting on a single shoot, retakes are on most occasions unacceptable. Although some art directors, such as Mary Shanahan, are willing to take a chance on an unknown photographer, many prefer to work with established shooters who invariably hand in usable pictures the first time around. "If you produce exceptional work one day and inferior the next, the bad work will destroy you," Demarchelier warns. When a photographer's work fluctuates in quality, clients will wonder which end of the spectrum will be delivered to *them;* most will not wait to find out. "A fashion photographer can never relax his standards—and the bigger your name, the more famous you become, the more you must keep up the quality of your images."

Murray Salit, an associate at Biederman and Company advertising agency in New York, has worked with Demarchelier for many years on the Ellen Tracey account. "Patrick's percentage of retakes is the lowest of any photographer with whom I've ever worked, saving time, money and aggravation," says Salit. Fashion personalities being what they are, aggravation may be the greatest occupational hazard. But few art directors or editors are willing to watch their budgets dwindle while a photographer discovers he should be shooting on the bayou instead of in Bali. At times, of course, reshoots are inevitable; the model may be wrong, the location funky, or the hair, unmanageable.

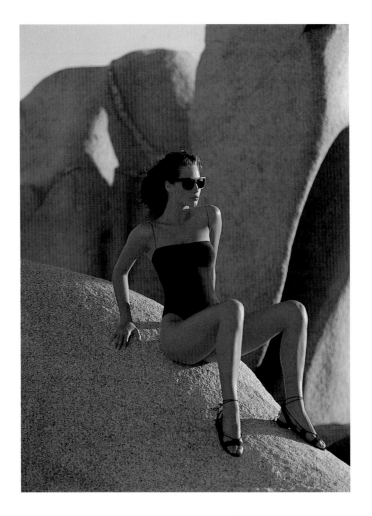

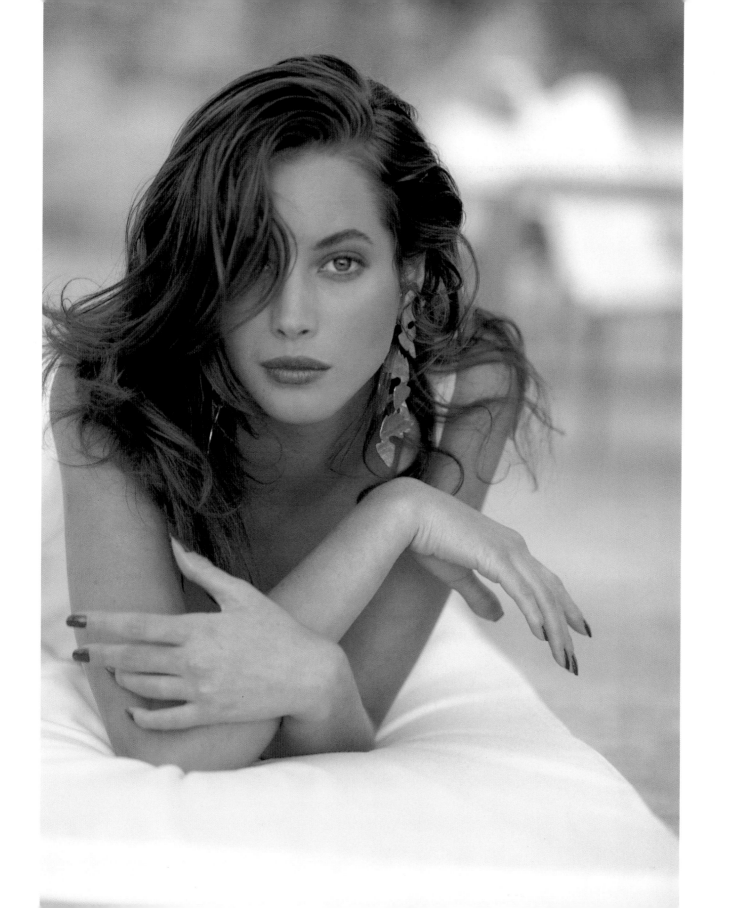

Still, the photographer will feel the repercussions if the photo is disappointing. The trick to good fashion work is to realize the fantasy in the client's mind's eye with a minimal amount of fuss.

Although the success or failure of a fashion image ultimately rests with the photographer, the process of creating a fashion photo depends on teamwork. Usually, once Demarchelier accepts an assignment, he is responsible for providing his own stylists, though he may occasionally honor a client with a specific personnel request and celebrities may arrive with their own hairstylist in tow. The photographer is the creative interpreter of the shot, but a number of people perform vital roles, including the assistants who change the film and set up the lights, the set stylist who tracks down the proper background vase or ensures that the model's earrings match (or fashionably mismatch), the hairdresser who creates a coiffure to complement the look of the designs, and the makeup artist who sets a color tone with her selection of eyeshadow or blush. Depending on the nature of the shoot, a fashion editor from the magazine may be present or—especially in the case of advertising work—an art director who has previously met with the photographer to present a detailed layout or describe the client's needs. Then, there's often a behind-the-scenes rep who brings the photographer's portfolio to clients, schedules jobs, and arranges many personnel and location details. The model is obviously an extremely important ingredient—he or she must possess the power to look alternately up and vivacious or enigmatic and subdued. For all to play their part to the hilt, the photographer must be open to suggestions.

"You may have your own idea about how a picture should look," Demarchelier says, "but someone else might have a better one." If an idea seems feasible—if, for instance, a stylist sitting at the edge of the set sees an angle that is potentially more evocative—Demarchelier is willing to listen. When he doesn't like what he hears, of course, he sticks with his own perceptions. "But you must be open to others, and sometimes the people you least expect will come up with the greatest solutions."

Chemistry plays an uncanny role as well. "When you're working with the best people in the world," says makeup artist Mary Greenwell, "it makes you feel good about yourself." Conversely, if someone isn't quite up to snuff, the others feel unbearably edgy. Demarchelier fosters a sense of self-worth in everyone on his team; he knows they're good at what they do. "It's a compact team and Patrick is openminded," says Didier Malige, a brilliant hairdresser often found at Demarchelier shoots. "He isn't the stubborn type." Adds Teri Shields, mother of Brooke, "He lets a model feel confidence

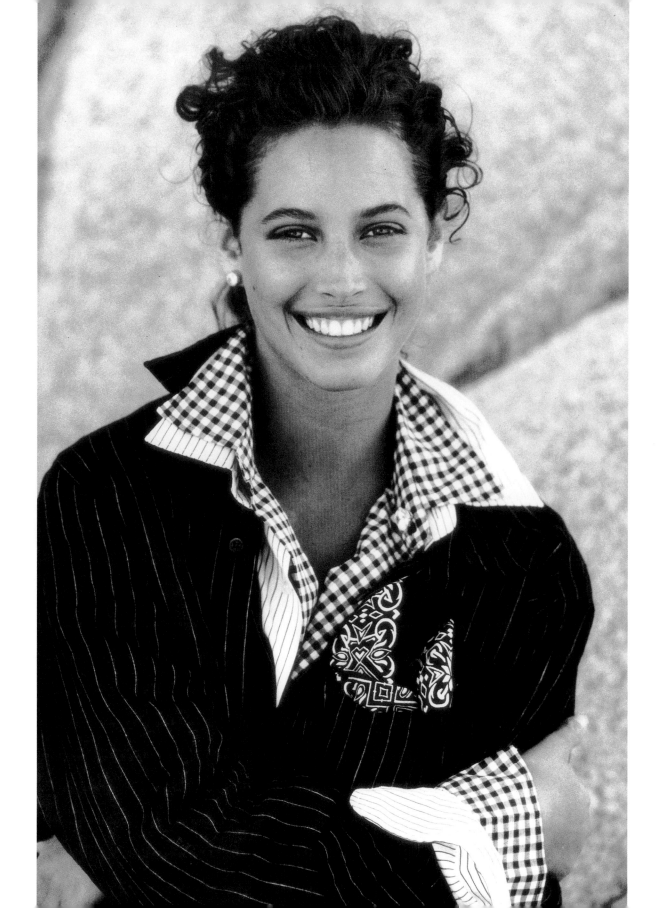

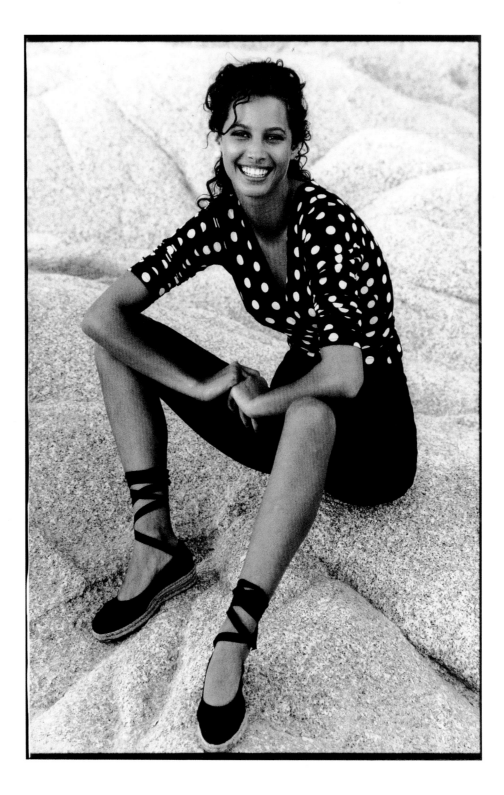

in herself, and once she has that her work will improve 100 percent."

Models themselves are tricky subjects. Above all, they are beautiful. Beyond that, they are human, and it is essential to the success of the picture that a model be a part of the camaraderie and teamwork, and not be placed apart. At Demarchelier's studio, models are treated as friends or relatives, not as visiting royalty. After all, even the best models have their imperfections, though a microscope may be required to find them. In the sixties, Lauren Hutton's gapped teeth suited the fresh look of the times; Twiggy's eyes were almost horrendously large; Penelope Tree was hardly a classic looker. Today, models like Paulina Porizkova, Christie Turlington, Iman, Cindy Crawford, and Tatjana Patitz have individual appeal, and each in her own way is regarded—at least by those outside the fashion world—with curiosity as well as awe.

Demarchelier is a favorite among models because he sees them as individuals. Though he is said to capture their natural beauty, he admits that he doesn't really understand women at all. To make a woman look "pretty or sexy" is all he sets out to do, yet by admitting that there are parts of women that he cannot fathom, he allows a merely beautiful woman to communicate her own exceptional mystery.

"Many photographers treat models like apples in a still life," says Paulina Porizkova, who has swiftly risen to the top of her field. "Or, they make us look like someone else—not like ourselves. Patrick is different. He always captures the personality of the individual girl." Adds Teri Shields, "He loves women, but he relates to Brooke more like a father, uncle, or brother." Perhaps Birrittella of Ralph Lauren expresses it best: "His photos are very *kind* to women. They make a woman feel sexy, exciting, and admired." No lurid suggestions lurk within Demarchelier's pictures; women as he portrays them reveal their sexuality, but never sell it short.

To hear a Frenchman say the word "sexy" is in itself a suggestive experience. But to see the way a Frenchman like Demarchelier recreates the word in an image is implicitly seductive. Fashion photography, since its inception, has been haunted by the pervasive power of sexuality. Even the well-mannered work of Edward Steichen, once deemed "the greatest living photographer" by Condé Nast, made women look desirable. The bottom line may simply be that sex sells, but to sell the right stuff to the right woman requires more than a bit of finesse; if the sexual message of a photograph is cheap, the image may not sell anything at all.

Patty O'Brien, a fashion editor at *GQ*, calls Demarchelier's images "steamy but tasteful." There is romance in his pictures, but not the sort created by more fantasy-

Dominique Nabokov

With Brooke Shields

oriented photographers such as Rebecca Blake or Deborah Turbeville. Demarchelier's women are quite knowingly sexy, and fully in control of their bodies. His work has a subtle but constant sensuality.

Still, it's not simply a matter of the photographer's own attitude. "I'm a photographer, not a magician," Demarchelier says. "A woman has to have the personality for the picture you want. If she is beautiful but is afraid to laugh, she may not be right for the part. Choosing a model for a fashion picture is just as important as casting for a movie."

Generally, Demarchelier works with female models, but occasionally he shoots males, notably for *GQ*. "Men are much more difficult to photograph," he says. "They're more self-conscious than women." Nor are men's fashions as visually exciting—fabrics and colors may change, but a suit is a suit. To loosen up his male models, Demarchelier prefers to bring women into his pictures as secondary players. "Men need a diversion to make them forget the camera is watching," Demarchelier asserts. "A man may be tense in a constricted studio setting, so another way to relax the atmosphere is to shoot on location." While Demarchelier often uses such top male models as Ford's Jeff Aquilon, he also employs "real people"—friends or acquaintances with interesting faces.

Ultimately, the fashion photographer is much like a conductor leading an orchestra of unruly, creative, and egotistical musicians. It's his job to keep the beat, not to repress the artists. As any musician will confirm, the most beloved conductors—and there are *few*—allow the musicians to follow their intuitions while upholding the composer's intentions. In much the same way, the photographer must respect and encourage the varied artistic impulses of those on his team while creating a cohesive image.

Since its discovery, photography has been the subject of controversy. In the mid-1800s, Daguerre and Talbot litigated over the invention of the process, and in the early 1900s, soft-focus pictorialists clashed with the hard edges of "straight" shooters. Later, those who shot in color vied with the conventional use of black and white, and critics complained that photographs lie while "concerned" photojournalists argued that they tell one truth or another. Though the courts ruled for Talbot's authority over the positive-negative process, leaving the daguerreotype to its namesake, many of photography's dilemmas remain unresolved.

The most often voiced and insipid question of the century—Is photography art?—has finally been answered in the affirmative. But fashion photography, because of its close connection to business, remains a grey area. Few would argue with the statement

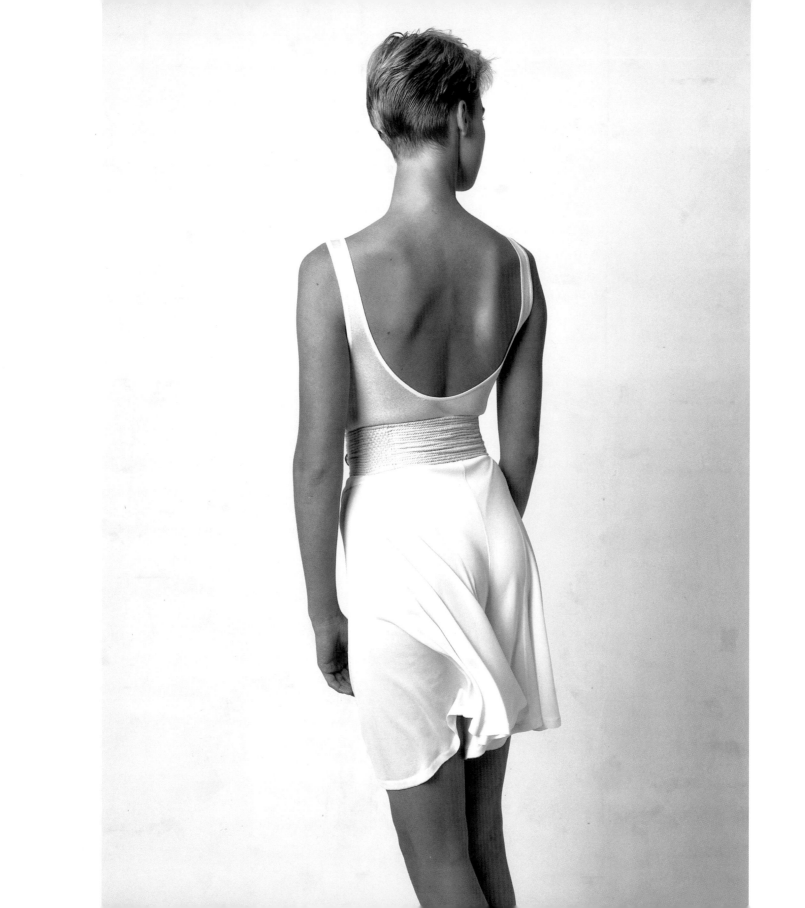

that Penn, Hiro, or Avedon have reached the stature of artist, but the term "artist" has generally not been extended to every photographer who shoots high-fashion models and *haute couture* frocks. Even though fashion photography has made its way into art galleries and museums in this decade (the International Center of Photography showed "Art and Advertising; Commercial Photography By Artists"; Norman Parkinson had a retrospective at the National Academy of Design; Rebecca Blake's fashion work played at Manhattan's Light Gallery), some viewers and critics still feel vaguely uncomfortable when fashion images creep from magazine pages onto exhibition walls.

Photojournalism has experienced a similar awakening in artistic circles, with a spate of color news photographs appearing in galleries. The best of the photojournalists, such as David Burnett and Sebastaio Salgado, have come to be regarded as artists apart from their craft. But great photographers from Edward Steichen to Diane Arbus and Jacques-Henri Lartigue have found artistic expression in fashion work, and many of the most gifted photographers have approached the fashion assignments they accept to make a living no less imaginatively or profoundly than their "personal" images.

Nevertheless, photographic art is often associated with a kind of subjective, expressive freedom that seems incompatible with the limitations of assigned work. But any art—even the most self-inspired and initiated—depends on strict discipline within a range of limits. The greatest challenges may not come from being able to do anything at all in any way one pleases, but in accomplishing a particular goal within certain boundaries.

A fashion photographer is limited in various ways, depending on the assignment. The art director may impose a certain layout, the clothing in many cases must be clearly shown, and the location—whether in a studio or a thatched hut in Malaysia—sets its own conditions. If, within this vise, the photographer can impart an individual style and create a photograph that is memorable and visually compelling, then art, it would seem, has been served.

"Fashion is not free—you work for a magazine, which you must help sell, and you must sell the clothes," says Patrick Demarchelier. "But the challenge is to do the best you can within those boundaries. It's almost a game; how far can you go and still remain between the lines?" As Rafalaf says, "Editorial work may be very experimental, but sales promotion is not. To be able to swing between those two extremes as successfully as Demarchelier does is a rare achievement."

"You must know the magazine and follow its policies," Demarchelier points out. "If you go too far—if you're just a little too crazy—they will kill the picture, and a fashion

photograph that is fantastic but never published really means nothing at all." Demarchelier takes some risks, but stresses that a photographer must know the section of the magazine in which the picture will appear before he determines how far out on a limb to climb. Every magazine has classic sections, such as monthly columns, that resist change, as well as areas in the feature well that are adventuresome and experimental. A photographer who submits a photo of a punk, offbeat girl to an editor seeking an elegant, sophisticated image won't last long. "Some magazines are more conservative than others. American publications are generally straighter than European magazines," Demarchelier notes. Traditionally, American magazines have a broader base of readers, so they can't afford to take quite as many risks as their European counterparts. Even today, "there is more fantasy, more costumery, more playing with the clothes in unrealistic situations," in the European press, asserts Polly Mellen.

Freedom is qualified, even in art, and like the composer who must follow the stylistic rules and rhythms to create a fugue, or the novelist who must create a palpable world within a few hundred pages, the fashion photographer must work within the confines of the editorial or advertising assignment while meeting his own goals. Not every photographer has found this challenge either rewarding or desirable; André Kertész was embittered by his experiences at Condé Nast, where he felt his artistic impulses were stymied and misused; Hoyningen-Huene once overturned a lunch table on *Vogue* art director Dr. Agha because he felt his artistic freedom was being jeopardized.

The art issue raises many preconceptions and fosters a number of fallacies; one is that a man or woman who makes it in the business world can't possibly be a true artist. Increasingly, artists are finding ways to be creative and still carry business cards, for they have learned through experience that in order to survive they must occasionally step into the world of commerce. The greatest challenge, in fact, may be faced by those who struggle to uphold their ideals while meeting the demands of a client.

Still, the fashion world generously provides another kind of freedom. Says Demarchelier, "I can work or not work, decide which jobs suit me, stop for a while if I need a change. Every day is different, with different people. The longest assignment may only last a couple of weeks, and each set of people and pictures is unique. Freedom in this sense is important to me."

All photographers have their own habits and work rhythms that make their careers personally and professionally satisfying. There are some who bark orders and chain smoke, and others who show up at the last possible moment, relying on the competence

of their assistants. Demarchelier falls into neither of these categories; editors and clients say he makes everything *seem* easy.

"He doesn't overexcite himself," says Paulina Porizkova. "He's so laid-back that sometimes I think he's imagining himself out windsurfing. Sometimes he's clicking and telephoning people at the same time, and it seems that he's not even looking at me—I'm always amazed at how wonderful the pictures come out." Demarchelier is the only photographer with whom she will work in the evenings. "I don't work at night as a rule," she says, "but with Patrick I never feel as though I'm working."

"Some people work better with bad vibes around them," says Demarchelier, "but I don't think you should be suffering and sweating when you make an image. I want to be relaxed, and to enjoy myself. People who are nervous and insecure bring attention to themselves and that takes away from the creation of the photograph. I'm not concerned about every roll and picture I take—I use a lot of film, because I am concerned about finding the right moment." Demarchelier shoots like a filmmaker, using three to twenty rolls for one photograph, depending on the assignment and the effect he wants.

His easygoing manner is not merely a personality trait; he consciously tries to remain calm in frantic surroundings. "What I most admire about Demarchelier, aside from his competence, is his ability to concentrate on the job while twelve people are milling about, many of them hysterical," says advertising associate Murray Salit. "He isolates himself to concentrate on his craft. With stylists, clients, makeup artists, and hairdressers, all with individual needs, Patrick is unflappable. This is a positive trait to bring to the fashion industry, which is accustomed to operating on the edge of chaos. He brings in his simple 'Don't worry, Murray, it's going to be beautiful'—a sustained feeling of calm."

Demarchelier doesn't collect things or dwell on the past. (He accidentally destroyed all his pictures made prior to five years ago through improper care and storage—a problem he has now rectified.) He claims to "live in the moment," and feels that worrying about mistakes can clog creative production. If people send out "bad vibes," he doesn't hire them. If clients are nasty or inhospitable, he says he's too busy to work for them. One suspects that when Demarchelier gets up on the wrong side of bed, he simply gets back in on the other side and goes back to sleep.

And yet, his working methods contradict this seemingly laissez-faire approach. "Learning photography is like training for a sport—like running a marathon," he says.

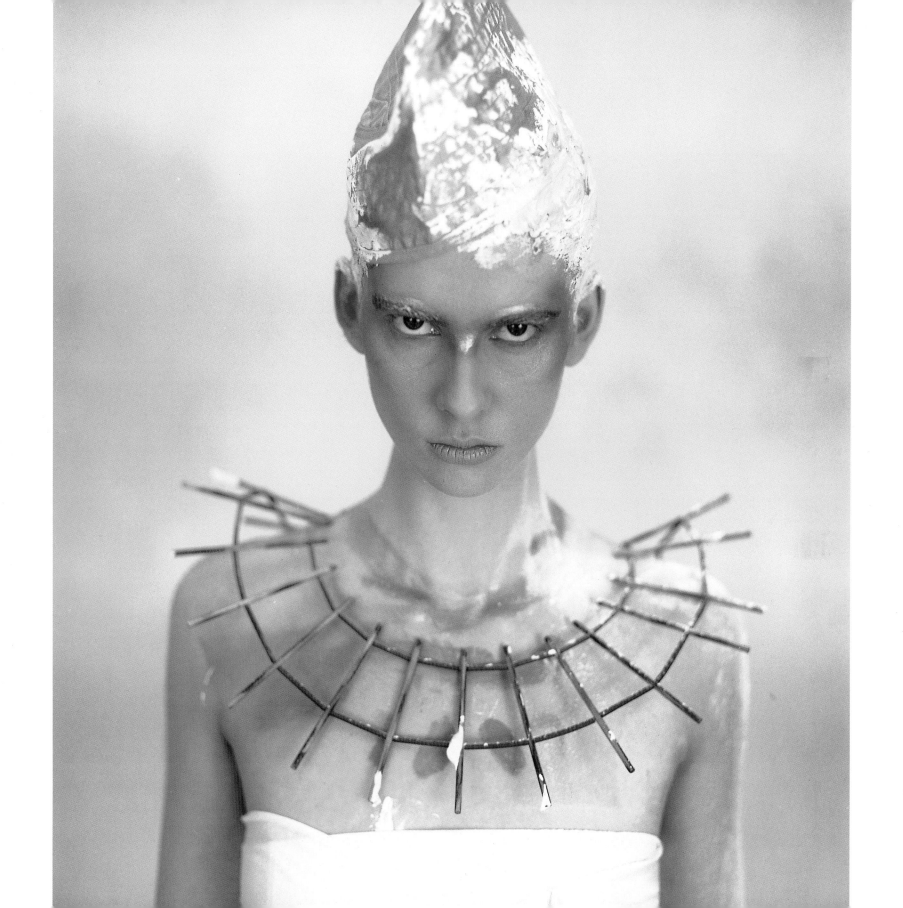

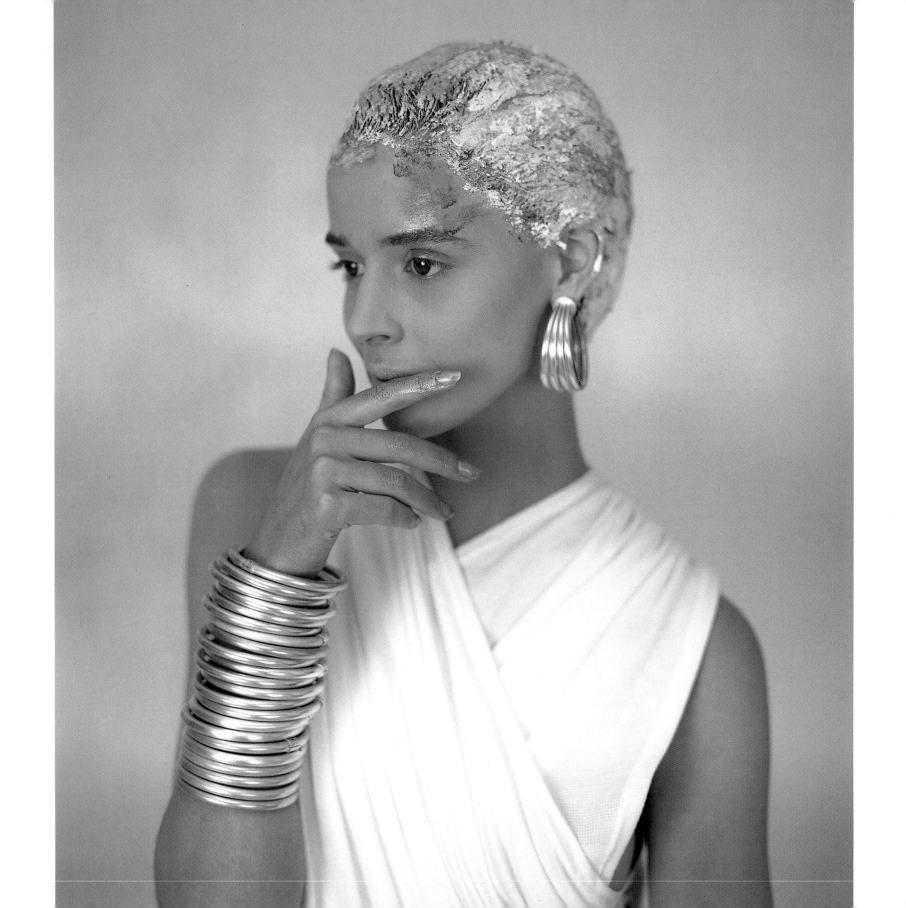

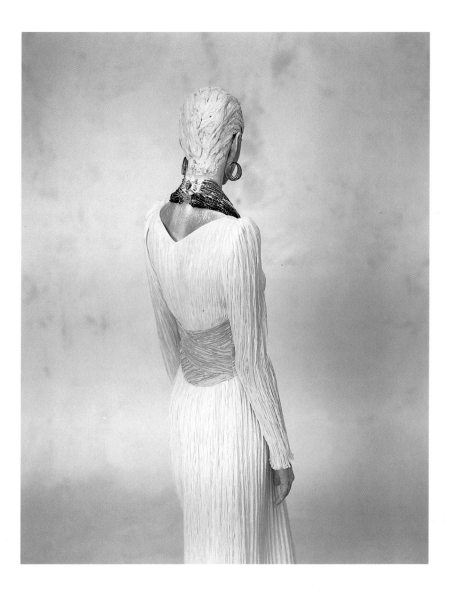

"You may be the best runner in the world, but if you don't train you won't win. You need to practice photography, and learn from your mistakes. When you fail, you learn more than with success—you learn to question what you did wrong. Working at something wakes you up." When Demarchelier began making photographs, he shot prolifically, defined his "look," and built the strong framework upon which his carefree nature now so comfortably rests.

"Though he seems not to care, he cares very much," observes makeup artist Mary Greenwell. "He is a thinking man." Demarchelier fiercely insists that things be perfectly achieved. On a fashion set, the actual shooting takes place at an allegro pace, although hours may be spent on makeup and hair or on finding the right location. Once shooting begins, Demarchelier stays alert to ensure that not a single detail is overlooked. "You can't be lazy," Demarchelier cautions, "and you can't be afraid to keep people longer to meet your objectives, or to stop the sitting and return to it the next day."

Demarchelier is a perfectionist with patience. A fashion photographer may have to wait hours for the light to be right, or cajole and humor a model until she's in the appropriate mood. Though this cool monsieur nice-guy might get cranky if he's cooped up in his studio for more than a few days, Demarchelier knows how to wait. He doesn't pressure his subjects, but draws them out.

Jim Abel, a freelance photographer who was creative director at Revlon when Demarchelier first came to New York, recalls perching on a roof with Demarchelier for eight days in Morocco, waiting for a perfect sunrise. He also remembers returning to a resort in Biarritz numerous times, waiting for the fog to lift. It never did, so the shot was achieved in South Hampton with French flags, a Parisian waiter, and café tables. Patience and adaptability are as essential to fashion work as a rainbow selection of seamless backgrounds. When a trip to Egypt for British *Vogue* was canceled at the last moment, Demarchelier shot the assignment in *Vogue*'s London studio. To create an Egyptian atmosphere—an Old World, bleached-by-the-sun look—he brought in an artist to paint a monotoned backdrop while Didier Malige bathed the model in white clay, placing odd, geometrical shapes in her hair. The resulting photographs were as reminiscent of an ancient and mysterious past as a sultry afternoon on the banks of the Nile.

Adaptability and imagination are needed in less exotic circumstances as well. Demarchelier once photographed model Gail O'Neil lounging on the beach with an oversized inner tube (see pages 14–15). The tube acted as an exaggerated sculpture, its bold, spheric lines harmonizing with the stealth and grace of the model. Demarchelier often uses natural or familiar elements in a way that seems entirely new.

In fashion work, where creative personalities often collide, it may be more important for photographers to possess a healthy insouciance than a predetermined map to visual perfection. That doesn't mean they must compromise their artistic goals or bend to the whim of every art director or editor encountered, but they must somehow reach beyond the frenzy that surrounds them, stepping ahead of the pulsating rhythm that moves the fashion world.

Although Demarchelier nurtures his personal approach to fashion, he is versatile, moving from fashion to celebrity portraiture, nudes, or beauty shots with confidence. "I don't like to do the same thing all the time," he says. "If you establish yourself only as a fashion photographer, you put yourself in a position to be bypassed one day. I like to do everything—to show different parts of myself, to be considered a photographer, not a certain *kind* of photographer only." In this way Demarchelier has marketed a personal style as deftly as the individual designers whose styles he photographs. Rather than tell too much about a specific way of working, he encourages the perception of himself as a man open to possibility, just as a designer creates an aura of mystery around a product line. In fashion, to define too definitively is ultimately self-defeating.

Fashion photography, as Grace Coddington points out, presents many options—a stylized picture in the studio, or a photo of a model running on the street; a photograph that clearly shows the color and lines of a dress, or one that suggests only the tactile sensations of fabric. "Patrick can go a number of ways without losing quality," she says. Clients expect to see more than one approach, adds Miaja Veide, senior art director at McCann Erickson, the ad agency representing L'Oreal and American Express. "I like to offer my clients several alternatives," Demarchelier explains, "and sometimes I like to surprise them and give them something beyond what they've asked for." Although advertising clients often give specific instructions, Demarchelier has found that clients, who are spending a great deal of money on a model, photographer, or ad agency, appreciate alternatives. If the idea they originally envisioned doesn't turn out to be the right one, they can choose from the other options, all made while the cast of fashion characters is still intact.

This kind of versatility requires a love of spontaneity. If photography has learned anything in the past century, it's that chance can be a far better friend than planning. From Man Ray's accidental rediscovery of the photogram to Jacques-Henri Lartigue's pictures of cousins tripping down stairways or diving into ponds, photography has embraced the unexpected. "In the fashion world we're always nervous because we don't know exactly what will happen, but we want something original that's never

happened before," says Rochelle Udell, associate editorial director at Condé Nast Publications. "It's an unpredictability that we live with and almost try to generate in the fashion world."

Demarchelier may use subtle improvisation or overt outrageousness to create a spontaneous moment. If the clothes are not particularly exciting, he might rent an expensive yacht to enhance the mood—an effect that would be hard to miss. Or he might photograph *haute couture* in a very casual manner, or sportswear in a stylized setting. "People like to see variation in magazines—something natural and fresh." Sometimes Demarchelier plays the voyeur, shooting with a long lens to surreptitiously capture his subject; at other times he shoots closeup in a direct manner. He might photograph in black and white when in the Bahamas, surprising us with an evocative mood and unexpected absence of color. Always, he is concerned with the quality of light and its effect on the mood of an image. He is as willing to see potential in a small corner of a room that is delicately illuminated by sunlight as he is to experiment with strobes and studio equipment.

This concern with variation does not indicate a weakness of direction. A roving eye may be more sensitive to what it sees than one that becomes fixated, as if in a trance. "Patrick's eye is always darting—looking around the corners of life," observes *Vogue*'s Polly Mellen. In the fashion world, where almost anything seems preferable to being mundane or repetitive, a photographer must be able to create unique images using familiar components. Just as Avedon used elephants or snakes as a foil to his models, or Hoyningen-Huene devised a rooftop diving board to make it appear that his swimwear image was made at sea, fashion photographers today must be willing to take chances. Sometimes, they go overboard, creating unfathomable illusions that insult our visual intelligence and stretch the importance of fashion to extremes. But Demarchelier uses a versatile approach in the best of all possible ways—to solve compositional problems and create an individual mood for each picture he makes.

In photography, the difference between a recognizable and repetitious style is a thin tightrope, but Demarchelier's images balance gracefully; each has the Demarchelier "look" as well as its own identity. He has a knack for maintaining a light, natural impression without becoming clichéd, and for letting his individual outlook blend casually with his subject and setting. "Each image is a challenge," Demarchelier often repeats. This kind of mantra can give a fashion photograph lasting life.

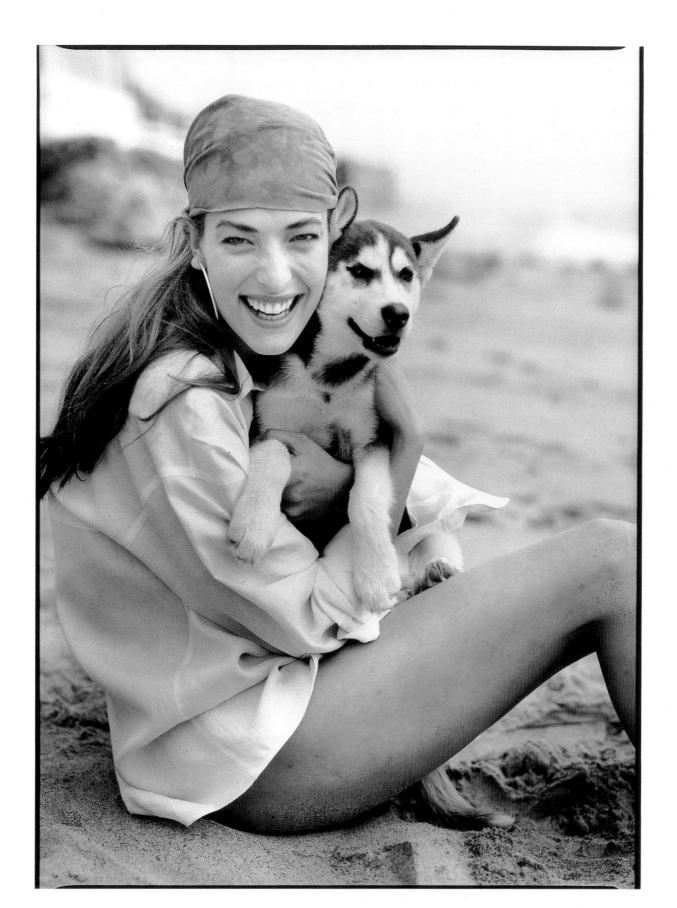

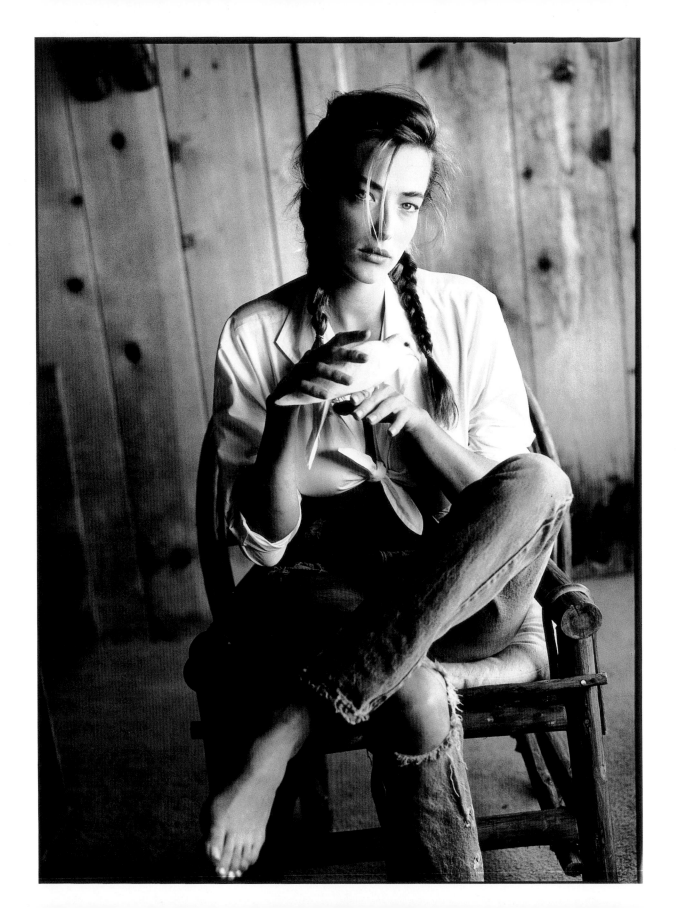

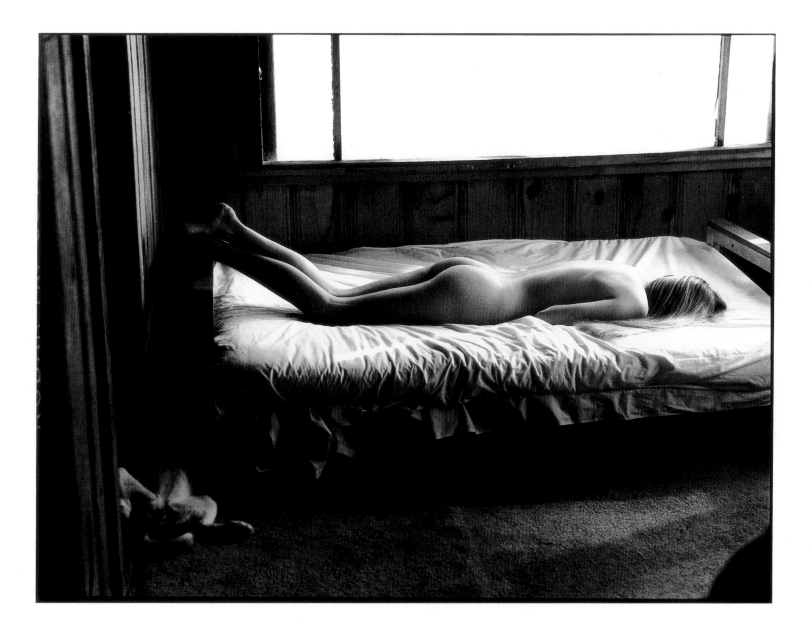

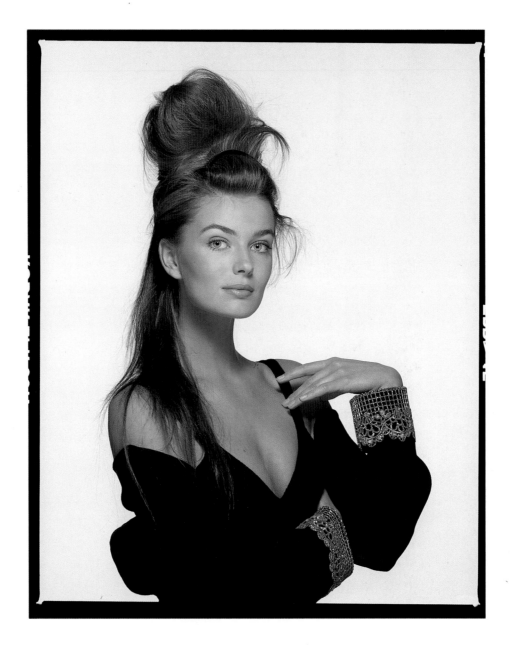

ON LOCATION

It's a sunny morning in the Demarchelier studio, just off Seventh Avenue in Manhattan's fashion district. Elizabeth Tilberis, British *Vogue*'s fashion director (who has since become the magazine's editor) and Mary Greenwell, a makeup artist who regularly commutes the Paris-London-New York circuit, are discussing some fashion sketches for a forthcoming issue. Patrick Demarchelier arrives at 9:30, when comely model and actress Paulina Porizkova is also due. "Will she be on time?" Tilberis asks Demarchelier, after receiving a kiss on each cheek—the photographer's customary form of greeting. One might wonder why the sleek, Czechoslovakian-born beauty who sits atop the modeling world would arrive *anywhere* at such an unfashionable hour, and apparently Tilberis is wondering this, too.

"Oh, she *might* show up by noon," Demarchelier quips with a prankish grin.

But by 9:45 Paulina is tucked comfortably in a deck chair before the mirror while Greenwell applies her makeup—"a very light touch, which Patrick prefers." While she is being made up, the model is off limits for conversation, but Porizkova doesn't seem to be the chatty type anyway; she's austere but gracious. Later, while Didier Malige, an affable, pony-tailed Frenchman, sculpts her voluminous tresses into a glorious arrangement, the repartee builds, especially between Demarchelier and Paulina. "Didier is the best—a master at work," Demarchelier confides within the hairdresser's earshot. The sense of teamwork is palpable, and the spirited camaraderie is more reminiscent of a cocktail party than a meeting of the busiest hands and minds in the high-fashion world.

Tilberis takes time out from ironing a blouse ("fashion editors do everything in this business") to show Demarchelier the clothes for the day's shoot. His gaze skims approvingly over the apparel before he returns to the roomy couch where he's been watching the Iran-Contra hearings on a portable television. Demarchelier is fascinated by "Geopolitics—the great moves," and watches the news with rare acuity.

By 11:30, Paulina is made up, coiffed, clothed, and ready to dazzle, and Demarchelier springs up with an animated clap of his hands. Wayne Takenaka and two other assistants have readied the set: a plain white seamless backdrop with black boards on either side, a ream of white paper on the floor, an overhead banklight, an Ascor QC 1000 strobe set at 800 watt seconds, as well as several Swedish Pro 3 1200s and a Mamiya RZ 67 camera with a 180mm lens and EPR 120 film. The Mamiya is a particular favorite for covers because the large 6 × 7-inch frame size offers better reproduction quality for magazines, and, placed on a tripod, the back rotates—ideal for studio work.

Although Demarchelier often uses a standard white background for his British *Vogue* covers, he alters the light for each model depending on the structure of her face. "Every face is different, and requires a unique quality or direction of light," Demarchelier insists. "There is no recipe for making a fashion picture or cover. You must adapt to each woman." In the studio, Demarchelier often uses a banklight and may employ a combination of tungsten and available daylight. For models on the move, a strobe is used to freeze the action. Outdoors on location, Demarchelier prefers a smaller, more accessible format, so he brings along a Pentax 4 and one-half or 5 × 6 with 50–600mm lenses, or a Nikon equipped with lenses ranging from a wide-angle 45mm to a 300mm.

Demarchelier stands on a slim piece of wood that raises him just above Paulina's eye level and makes a Polaroid. This common studio technique indicates whether the lighting is balanced on the background and face, and assures the stylists that hair and accessories are in place. This particular test shows that the light is too strong, so Demarchelier helps Wayne move some plywood to block the light from the studio windows. Paulina scrutinizes the Polaroid and nods approval, whistling while Greenwell powders one glistening shoulder and Malige sprays her hair and tucks back some stray wisps. Then, to the low music of the radio, Demarchelier begins a pas de deux with Paulina. "*Tres jolie!*" Demarchelier calls out. "*Fantastique!*" as Paulina varies her poses and expressions. Clicking her tongue at no one in particular, Paulina notices that her watch is upside down and makes a quick adjustment. Then she smiles and removes a bottle of hairspray from the white reflective table in the foreground, shaking a friendly finger at Malige. A fan on the right blows a gentle breeze through her hair and everyone holds still. "No walking!" Demarchelier bellows heartily to those contemplating a stroll around the set: the camera must be as steady as the eye. "Who is zee disc jockey?" he questions as an ice-cream commercial limns the atmosphere. Wayne makes a beeline to the stereo system.

After a lunch of sushi and Heineken beer, the hairdresser and makeup artist converge upon Paulina again. Demarchelier's teenaged baby-sitter arrives, on an hour's respite from the photographer's trio of boys, to observe her employer in action. Demarchelier paces about the studio and chats incessantly on the phone in French; it seems that much of a fashion photographer's day is spent waiting for others to do their jobs, and it becomes apparent why Demarchelier's patience is so lauded a virtue. Back on the set, Tilberis peers through the lens (which may have disturbed the likes of Louise Dahl-Wolfe, who resigned from *Harper's Bazaar* when an art director had the presumption to look through her ground glass, but not Demarchelier.) Between rolls of film, the photographer and model banter about Demarchelier's *Newsweek* cover of Paulina which has not yet run. "Maybe after Jim and Tammy Bakker I'll get my chance," Paulina jokes. During another series of shots, she smiles and crosses her arms over her breasts, her brows arched high, her gaze piercing the exact center of the camera lens. "*Nice*," Demarchelier sighs with emphatic satisfaction: it is the moment that will later become the British *Vogue* cover.

"Coffee?" Paulina purrs, reminding Demarchelier that he has promised a break. While the model rests, he looks over some black-and-white portraits with his printer, Cameron Stewart, pointing out the desired areas of contrast. Wayne peruses some color film from a previous shoot that has just come back from a clip test. This test involves the lab clipping off a frame, leaving the rest undeveloped. After examining the clipped frame, Demarchelier can instruct the lab to "push" or occasionally to "pull" the film during developing. By processing the rest of the film for more or less time, adjustments can be made to assure perfectly exposed film. Though flash meters are used to get a good approximation of correct exposure, any number of conditions (a particular film emulsion batch, the color of a dress, the shade of a model's skin) can affect the final result. A two-day shoot may involve 300 rolls of film, not to mention the time of the photographer, model, and so forth, so it's critical that the results be technically perfect.

At 5:00, the group is back on set for a final series of editorial fashion pages. Paulina, dressed in high heels and a black body suit, valiantly maintains her balance while bending and stretching with serpentine prowess. Taking his place on the floor and shooting up at the model, Demarchelier prompts, "Try putting your hands behind your back—and be a little more playful."

"I *am* playful," she shoots back. For the most part, Demarchelier lets Paulina, a very polished professional at 21, take her own cues.

"I've worked with Paulina for many years," Demarchelier says later, "and I know what she likes. We create a mood together that comes in a natural manner—it's never forced." Both model and photographer are striving for a strong, intelligent cover that will attract on the newsstand—one that, as Demarchelier says, "makes you want to know her, to touch her."

As the set is winding up, a collection of male models has begun to flood the studio. On and off during the day, Tilberis has been reviewing their portfolios, culling just the right faces for a location shoot at sunset by the Hudson River. But by 6:30 the light is fading, and Demarchelier orders the models home until the next evening. The best-laid schemes of fashion editors, it seems, can fade in a passing second of sunlight.

Watching Demarchelier work, one begins to understand the fashion photographer's creative process, and to trace the energy that ultimately culminates in his pictures. Demarchelier sets a rhythm and paces himself accordingly—not too much too soon, but never too little, and never too late. He is constantly shooting, exclaiming, and reassessing, suggesting changes when needed and absorbing what he sees. Shooting up from the floor to create a dramatic perspective, or directly into the model's gaze, Demarchelier never misses a beat, a stylish shrug, or a movement. When he has what he wants, he knows it, and he lets nothing slide by. Though he is aware of every part of his team (and what each member is up to), he operates in his own discrete space. His vision is undistractedly focused on capturing the moment that will suit the glossy, high-glamour tone of a *Vogue* fashion page.

Though the day is over, one of the most important aspects of the shoot is yet to come. "Editing is a crucial part of the process," says Demarchelier. He initially edits his own film, making his choices before sending the selects to the art director or client. Although occasionally an art director's independent choice may delight the photographer, this is the exception rather than the rule. "The ideal is to work as closely as possible with the art director and to make the choice together as I do with John Hind at British *Vogue*," Demarchelier explains. An art director who fails to value a photographer's input has a disturbing power, for the very moment that the photographer sought to achieve may be overlooked in favor of a more marketable image. In the best of all possible worlds, art directors and photographers engage with mutual respect and cooperation.

COVERS

Shooting magazine covers requires a special flair; Demarchelier, who shoots covers consistently for British *Vogue* and has made covers for *New York*, *Life*, French *Vogue*, *Marie Claire*, *Rolling Stone*, and *Vanity Fair*, apparently has it. "When confined to a closeup cover it's really difficult to get a different picture every time," says Grace Coddington. "Demarchelier is always able to get life into a very small space."

Because the cover is the calling card of a magazine, editors and art directors are particularly obsessed by each month's cover shot. Unless a magazine has a contracted cover shooter—like Richard Avedon, who creates all the American *Vogue* and *GQ* covers, or Francesco Scavullo, who every month turns his lens on a new *Cosmopolitan* girl— conveying the magazine's character in a single shot can be an extremely vexing problem. Says one editor of a major monthly, "Each month you have to figure out what will sell and what it is about your magazine that will stimulate the reader. You want to be provocative, while considering the point of view or taste of your reader—who may range from a closet radical to a right-wing religious zealot." Even if the magazine goes for a consistent "look," it's crucial to get a different spin or twist. "The cover/blurb combination has to be dynamic, but the biggest challenge is translating your ideas into photography, and getting a model to exude the right attitude."

Demarchelier's success at shooting covers is linked to his perceptive understanding of how a magazine sees itself. British *Vogue*, for example, likes a more sophisticated look, while *Glamour* and *Mademoiselle* project a younger, more playful image, and *Elle* might require a portrait that's a little offbeat. In America, covers may be slightly less important than in Europe, because U.S. publications rely heavily on subscriptions. Abroad, newsstand sales are more essential.

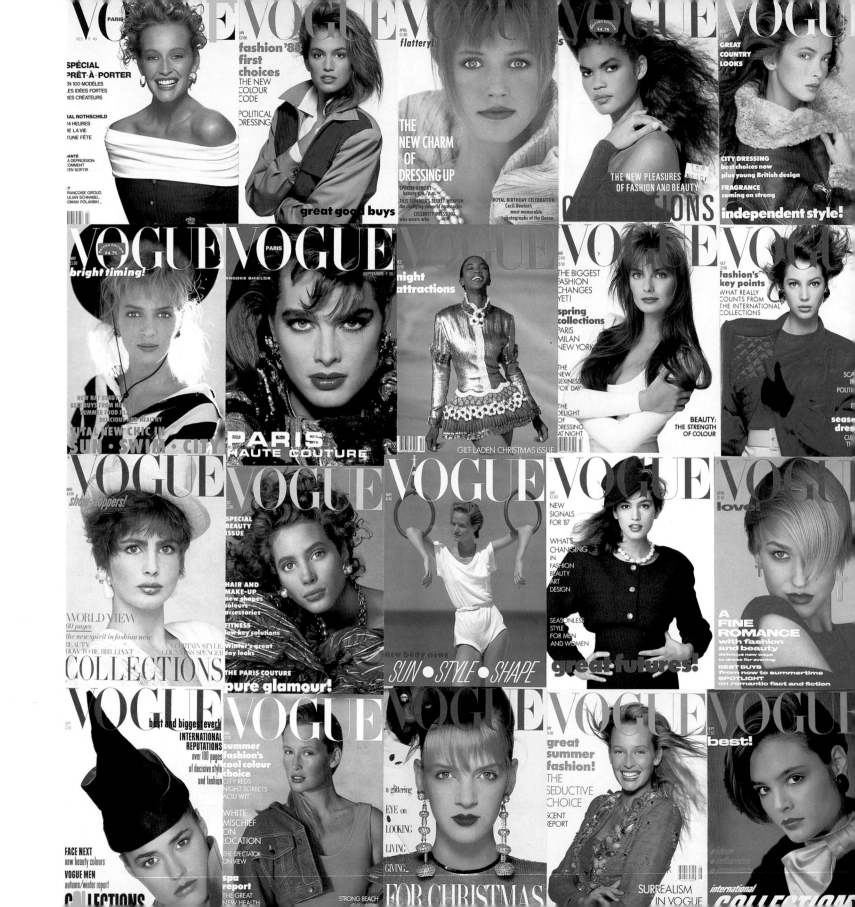

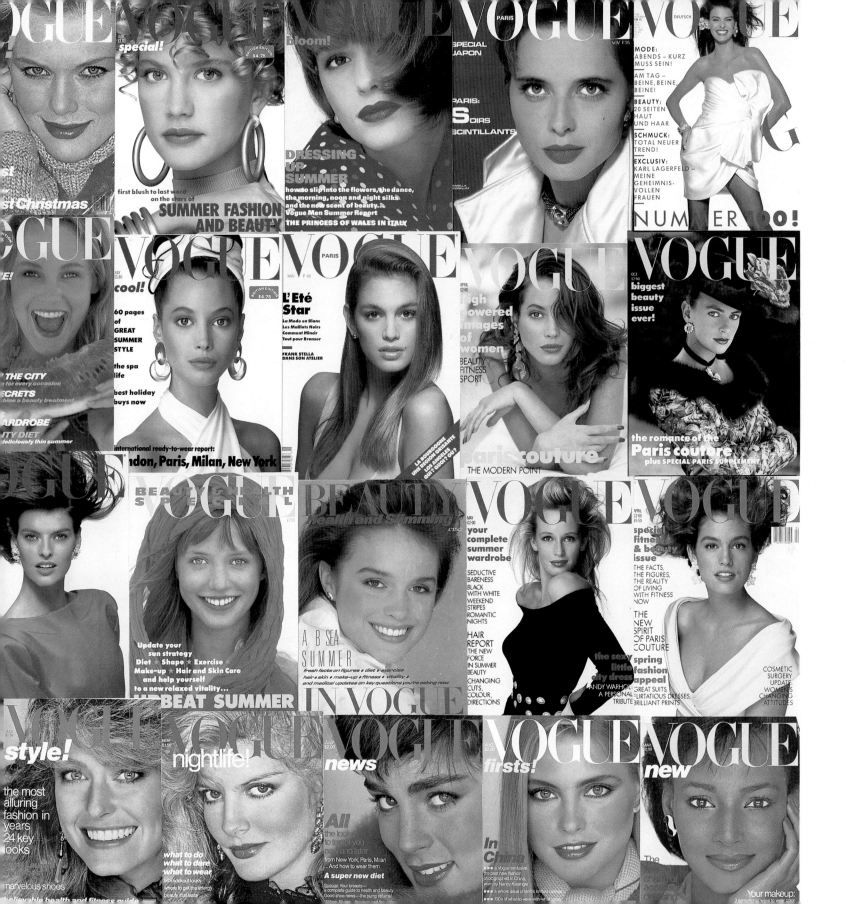

In general, Demarchelier explains, a cover requires direct eye contact: the model must charm the passing stranger with her expression. Demarchelier learned this lesson well when he shot a cover for British *Vogue* that didn't fit these standards—a distant view of a model in white sportswear, her gaze wandering off to the side. Although the photo was graphically effective, it was the year's worst seller.

"Not every model is right for a cover," Demarchelier notes. "Models who are too young may not be mature enough to project the right expression. A cover model should not look passive, and should not appear to be waiting to be photographed. She must be very positive, and project an aggressive, optimistic attitude."

A glance through Demarchelier's cover portfolio reveals the variety of images created within the confined frame of a cover shot. For *Vanity Fair*, a vivacious Bianca Jagger holds diamonds to her ears, her arms bent above her head. For British *Vogue*, fresh eighties model Christie Turlington shows off a lush Yves Saint Laurent jacket. A Demarchelier cover, like his other fashion work, has a strong identity, yet reflects a flexible working method. By moving in just a bit closer, he captures the full, alluring lips of Isabella Rossellini; stepping back, he frames Paulina Porizkova on a cartop seductively unveiled for summer for *New York*; with an eye for humor he snaps a clownish Warren Beatty/Dustin Hoffman duo for *Life*.

Condé Nast editor, Anna Wintour, frequently used Demarchelier for British *Vogue* covers. "His strength is the approachability that he brings to his pictures," she says. "We want a cover girl to look attractive, intelligent, and unique, but most of all to appear approachable. The photograph must have charm—it can can never be remote." *Vogue* covers also require a recognizable "look" that people will immediately respond to when they pass the newsstand, Wintour adds. The cover girl must be genuinely appealing and pretty, but she must also look real and modern—she must fit the times.

Most of Demarchelier's covers are shot in his studio with a Mamiya RZ 67 and 180mm lens in only a few hours, but a notable exception is a recent British *Vogue* cover that was shot outdoors. Demarchelier's operating method clearly mirrors the image he hopes to capture—his optimism and assurance as a photographer is the perfect complement for the cover girl's own confident style.

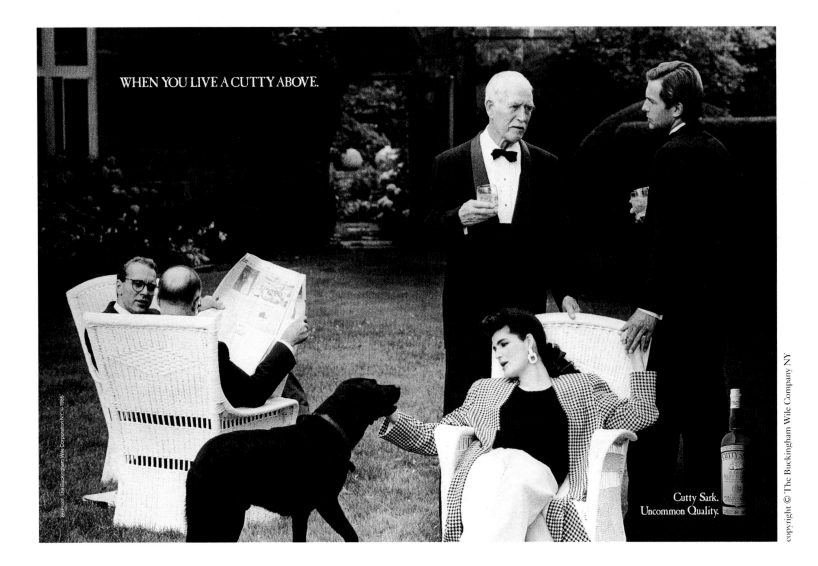

WHEN YOU LIVE A CUTTY ABOVE.

Cutty Sark.
Uncommon Quality.

ADVERTISING

In the 1920s, photography began a sort of indentured service to advertising, meeting the utilitarian task of illustrating hair creams or razors. But since then advertising has opened up a labyrinth of photographic directions. Perhaps all the hoopla began with Paul Outerbridge's 1922 Ide Collar ad in *Vanity Fair*, or when Edward Steichen turned his artful eye on cutlery in the thirties. By the fifties, when Bert Stern reflected the Gizeh pyramid in one slim but memorable vodka martini, advertisers had grown wise to the fact that profits expand in direct correlation to the persuasive power of photography, and photographers were quick to use advertising as a creative and lucrative means of making a living.

Although shooting for the editorial pages of magazines is challenging, advertising work is financially rewarding and allows a photographer an opportunity to use his technique and imagination to solve very specific problems. Advertising is generally considered more restrictive, however, and clients and creative directors may have distinct ideas about the way they want their products portrayed—how, why, when, where, and from what angle. But even in advertising, a photographer's ingenuity is a valuable asset, and most clients (at least, most with whom Demarchelier works) are open to suggestions. They may hand the photographer a detailed sketch of what they want, but many are willing to consider variations on the theme. In Demarchelier's view, layouts provide a *sense* of what is desired (and of course the agency uses it to snare the client in the first place). The photographer, Demarchelier believes, must give both the client and agency "a picture that *surpasses* the dream."

For Demarchelier, the most difficult client is one who insists on obvious, literal translations. Often, Demarchelier asserts, it's better to create a mood than to go for a closeup on the product (although Penn's elegant ads for Clinique reveal what can accomplished with a few dull bottles and a light source). But in fashion shoots, the

photographer may opt to clearly show the clothes, jewelry or accessories without producing what is disdainfully known as a "catalog shot"—an uninspired, ho-hum picture of the item to be purchased.

Demarchelier's approach is not merely one of artistic license; instead, this seemingly circuitous path serves a very useful purpose. If, for instance, the advertisement emphasizes only the specific color or style of one particular outfit, buyers who may detest themselves in chartreuse or pale at the thought of their thighs emerging from a mini, are immediately turned off and away. An image that conjures up a mood, that hints at the designer's style or suggests the activities for which the product might best be suited, may be more tempting than an image that clearly delineates the product itself. Demarchelier's successful series of photographs for the Calvin Klein clothing line is a perfect example of this method—images undeniably focused on lifestyles and attitudes, rather than the details of an oversized shirt or a black knit dress.

Calvin Klein, Demarchelier maintains, is the ideal client, because the designer and his troupe appreciate good pictures and are receptive to new ideas (no doubt Mr. Klein doesn't skimp on his budget, either). Demarchelier's only instructions were to "capture the sensuality of the clothing," recalls Rochelle Udell, creative director on the four-picture campaign.

Demarchelier took model Talisa Soto to some sand dunes in the Long Island Hamptons and asked her to engage in some rather erotic calisthenics. "I wanted to create an uncomplicated, sexy campaign even before I received the clothes. But when I saw how well the simplicity and beauty of the fashions matched up with the model, I knew that I wanted to make the most out of the way the clothing moved along with the shape of Talisa's body." As Soto moved, Demarchelier closely followed the way the line and shape of the clothing interplayed with the natural light and shadow of late afternoon. For variety, he shot one of the ads on a porch daybed, using an extra pillow as a prop and the ambience of natural light to soften the effect. All were shot with a Nikon camera with a 135mm lens and Kodachrome film. "I don't decide upon the look I want in advance . . . I pick up my camera and the look comes to me," Demarchelier insists.

"I'm a strong believer that when things work you're not aware of any one element. There's a magic that brings it all together," says Udell. "There were no extraordinary tricks going into this . . . the shoot was simple and direct." In the three-day session, Demarchelier created four distinct images that were joined by the thread of Calvin

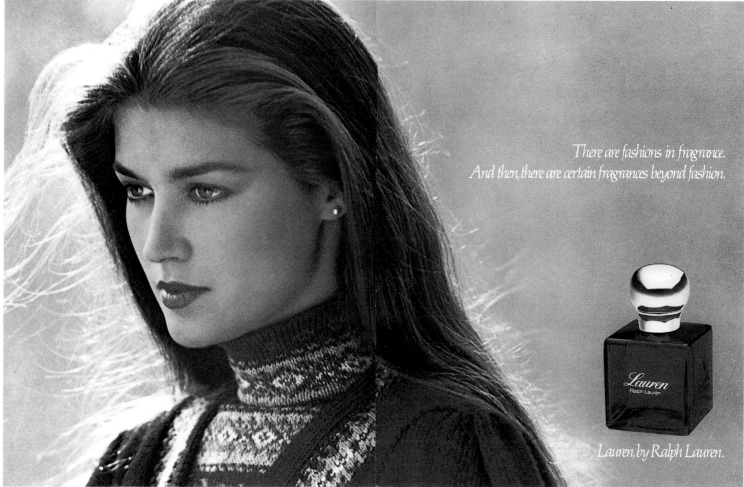

There are fashions in fragrance.
And then, there are certain fragrances beyond fashion.

Lauren, by Ralph Lauren.

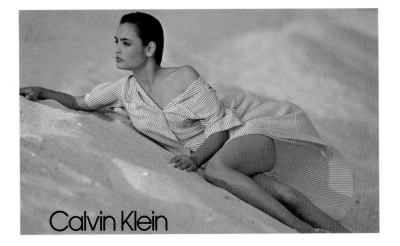

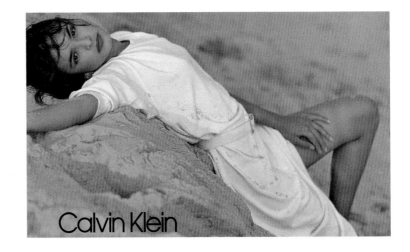

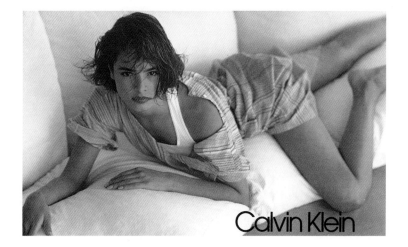

Calvin Klein

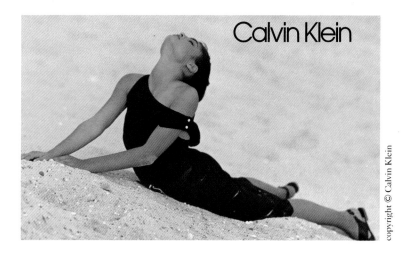

Calvin Klein

Klein's style—a romantic but decidedly sensual look that worked without artifice or brash tactics.

To create a descriptive mood for a product, Demarchelier strives for "stop appeal." In a magazine that has, for instance, 150 pages of advertising, an ad must be a bit racy or unusual—perhaps even tastefully shocking—to arrest the jaded eye of a confirmed page-flipper. Like the cover girl, the model in the ad must project her character and mix her femininity with a certain amount of aggressiveness. "If you get people talking about your ads, that in itself leads to free advertising," says Demarchelier; who can forget, for example, Bruce Weber's adventurously erotic Calvin Klein underwear ads for men, which kept people buzzing for days and news magazines covering the story behind the story? An advertising campaign may work well without an overt gimmick, but it must possess a visual catch—like fashion photographs, advertising images tend to blur together, and only those with distinctive, attractive qualities will find a lasting niche in the collective consumer memory.

Although a bold vision is usually required, a strong campaign needn't be pushy. For Ralph Lauren, for example, Demarchelier created a quiet but inviting mood to suggest the kind of woman who might be wearing the designer's perfume. Demarchelier was chosen to shoot the ads simply because he makes women look beautiful; there was "no heavy-duty advertising strategy," says Sandy Carlson, creative director at Wells, Rich, Greene. Carlson described what Lauren was after (and what Demarchelier delivered) as a "classic American beauty"—a look so straightforward and implicitly romantic that it couldn't be forgotten. In the Hamptons with a cool wind blowing, Demarchelier used the natural highlighting effect of the sun to put a glow on the model's hair. He dressed her in a deep burgundy blouse to add warmth to the image, shooting with a Nikon and 200mm lens with Kodachrome 64 film.

Like fashion work, advertising requires versatility—Demarchelier's approach to Cutty Sark blended Scotch whisky is very different from his ethereal fragrance shots for Ralph Lauren or his Calvin Klein beach charmers. Linda Vos, vice president and senior art director at Macnamara, Clapp and Klein, had studied the work of a number of photographers before deciding on Demarchelier. She was finally attracted to his stylish and spontaneous look, as well as to his strong black-and-white technique. Although the agency was working primarily with male models and Demarchelier had submitted mostly shots of women, Vos says, "It was clear that he got an identity from his models; they

were not just clothes horses to him." This was especially important to Cutty Sark because they were using "real people" in the campaign along with models. Most liquor ads are geared toward the youth market, but Scotch is generally considered an older man's drink, and so a stately friend of the stylist was used as a model. His dignified stance and features complemented the drink's reputation as the choice of a more mature and self-confident individual. The agency decided to include younger models as well, creating a scenario that suggested a mentor relationship or a leisurely meeting of (decidedly upscale) family business associates.

The photographs were made with a Pentax 4×5 camera and Tri-X film at a Great Gatsby-style house on Long Island. Although the general tenor of the ads was planned, "With Patrick it's more spontaneous than predetermined," says Vos. "At the time and place he likes to say, 'Let's try this or that and see what happens.' " Shooting about 120 rolls of film on each of two days, Demarchelier tried a number of locations—by the pool, on the lawn, in and outdoors—and took advantage of whimsical moments such as the appearance of a curious Labrador retriever on the set. Vos found that Demarchelier's low-keyed interpretation of the client's ideas paid off; in a declining market, she notes, Cutty Sark's shares rose 29 percent since the campaign appeared.

In Demarchelier's advertising work, one senses the atmosphere of a particular place, the mood of the day and the models, and the unique connection of the product to each of these elements. Demarchelier fully employs the power of suggestion; his method of "selling" has a subliminal effect. His scenes may be romantic but they are not unrealistic, and his message is one that consummately attracts, which ultimately is what the fine art of persuasion is all about.

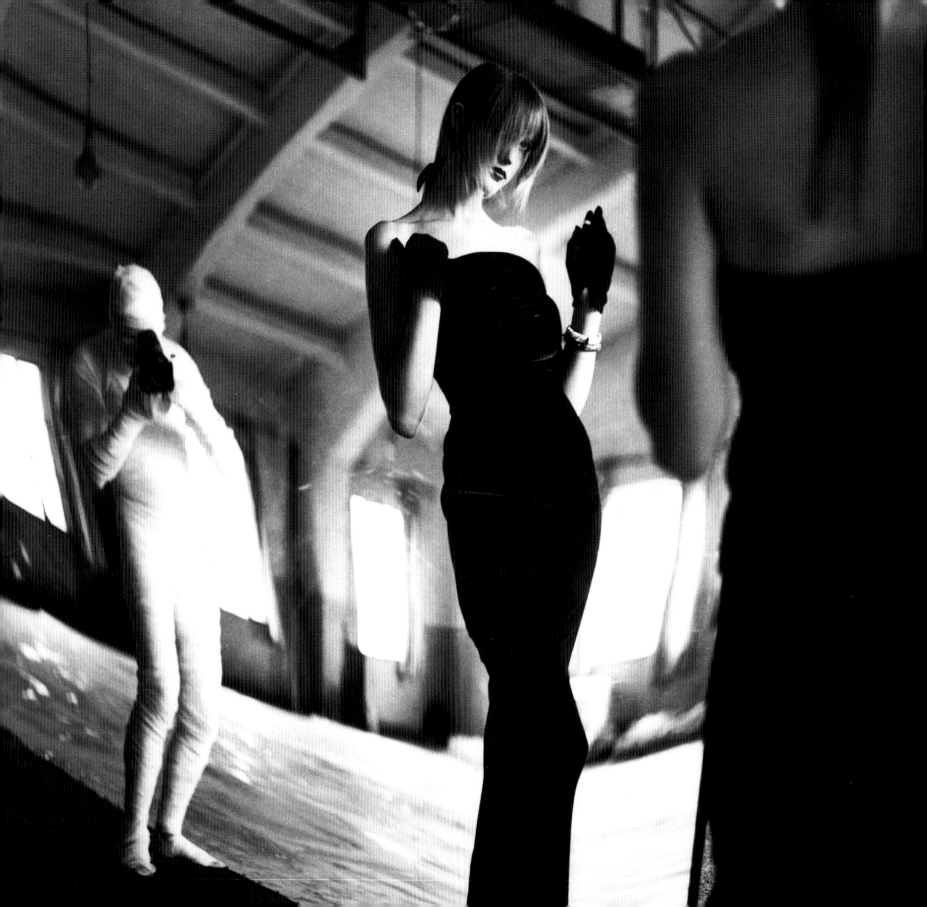

PORTFOLIOS

BOLD NEW LOOK

"Here are two vastly different approaches to high fashion. For one, shot two years ago for British *Vogue*, I used a graphic, bold approach. Didier Malige created these sophisticated hairstyles to complement the strong shape and direction of the designs. In these images, the hair was really the most important element, and the mood was a bit strange. I don't really plan these things, but after seeing the fashions, the feeling and atmosphere of the image come together and I know what I want to do.

"Because high fashion is traditionally so serious, this year we decided to explore a more frivolous, whimsical mood. I wanted my models laughing and enjoying themselves, so we stuck an ostrich feather in model Linda Evangelista's shoe to add to the spirit of fun."

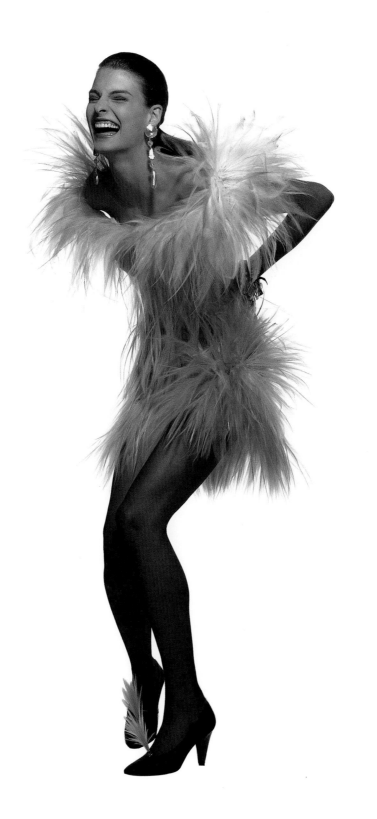

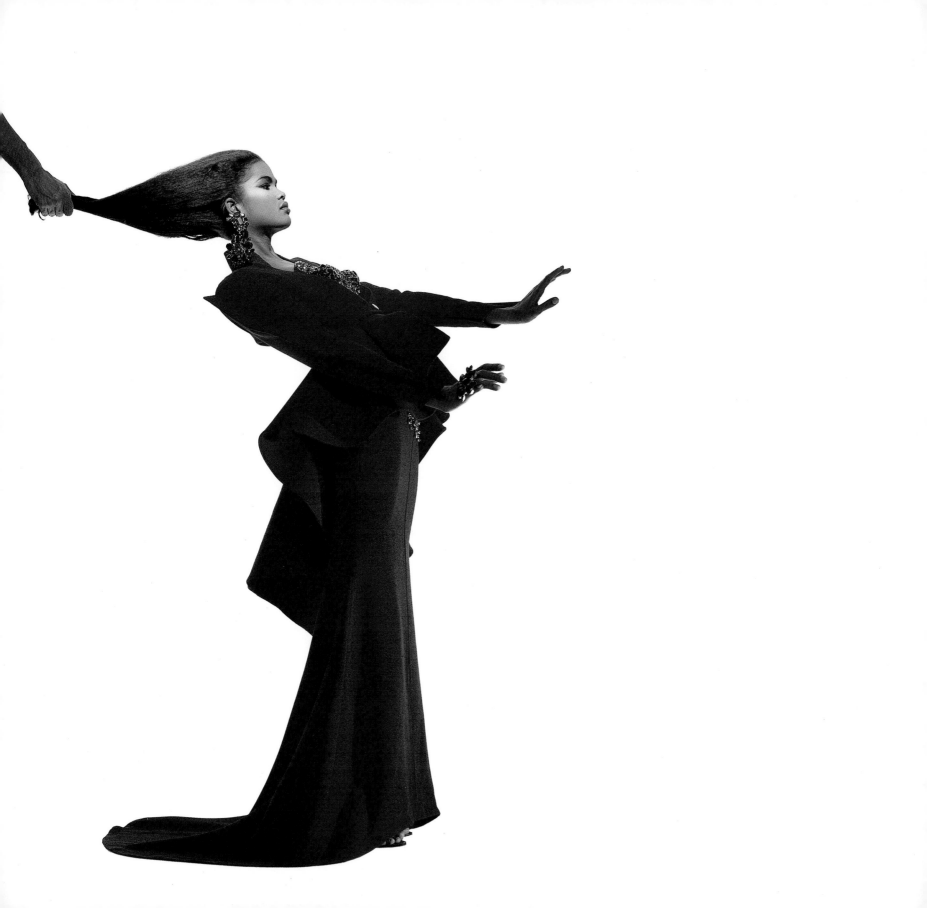

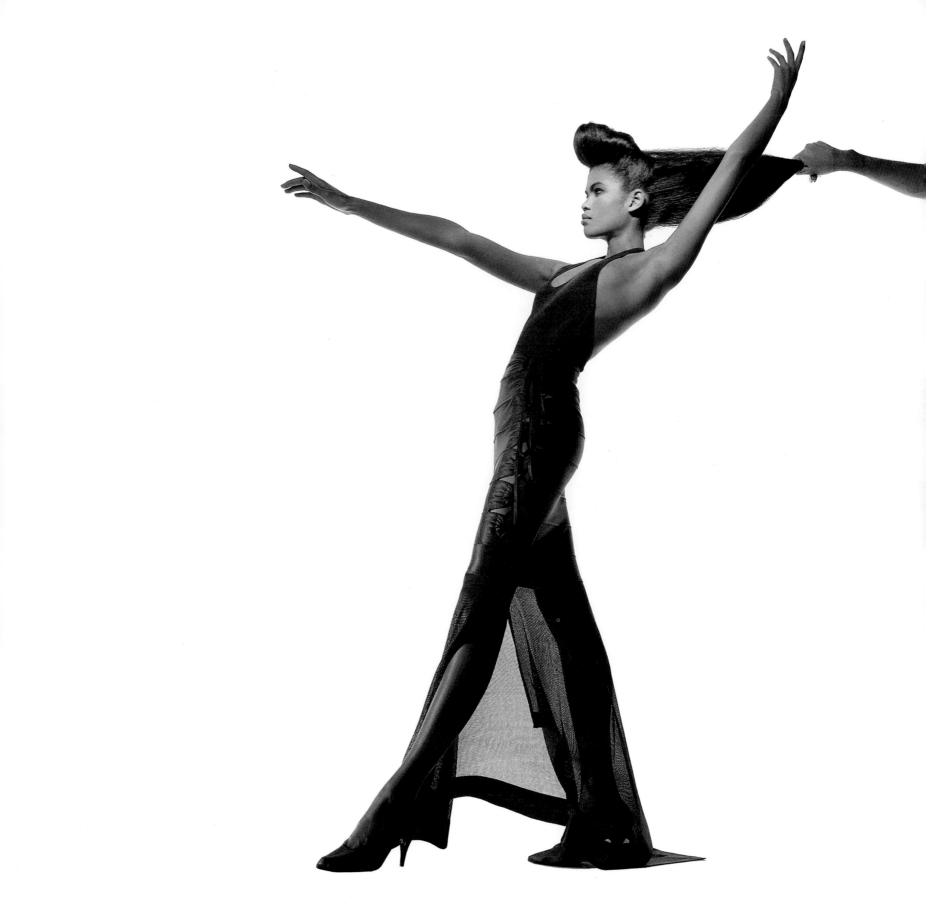

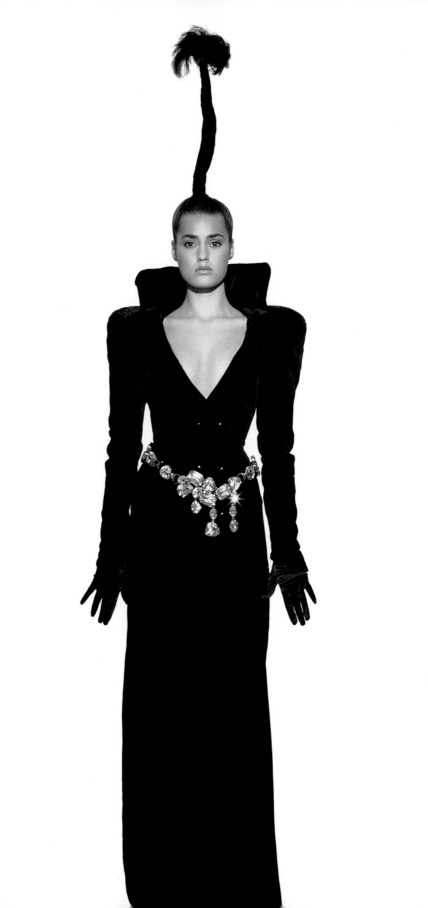

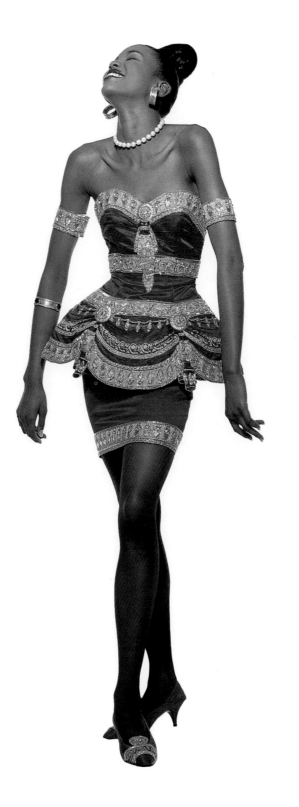

QUALITY OF LITHE

"This series, shot in 1981, was my
first major assignment for British
Vogue with Grace Coddington.
We sailed to Barbados and began
shooting in our hotel. Clothed in
a light, summery dress, the
model posed on a couch. Later,
we decided to pursue a sort of
acrobatic, healthy look to match
the more casual fashions. Since
there wasn't anything available
there to buy, we made our own
props. We used rope and tape
stored on the boat and con-
structed the swing and rings. Our
objective was simply to give the
model an attitude with which to
work, and to create a picture that
reflected the lithe quality of her
movements interacting with the
beauty of natural light."

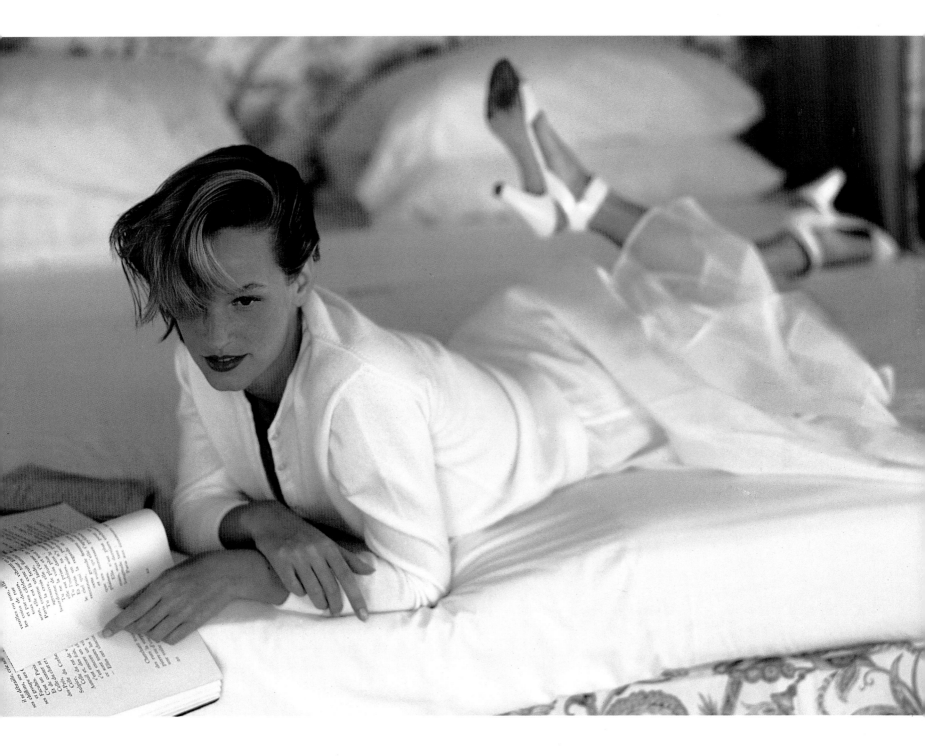

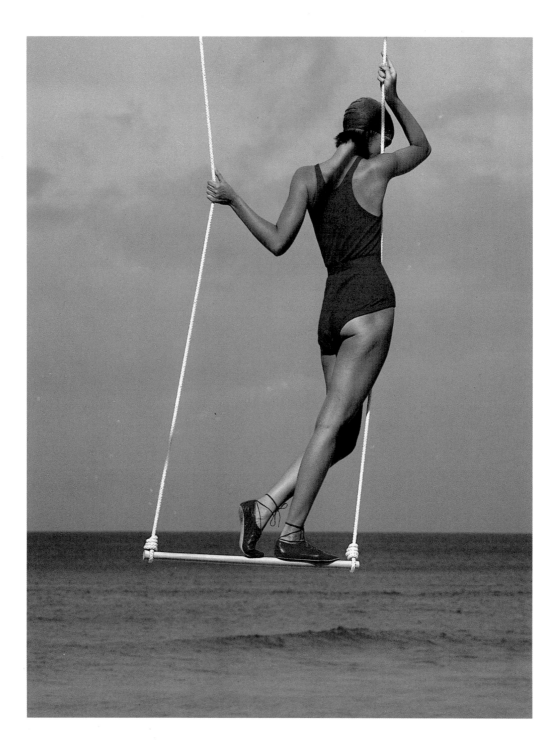

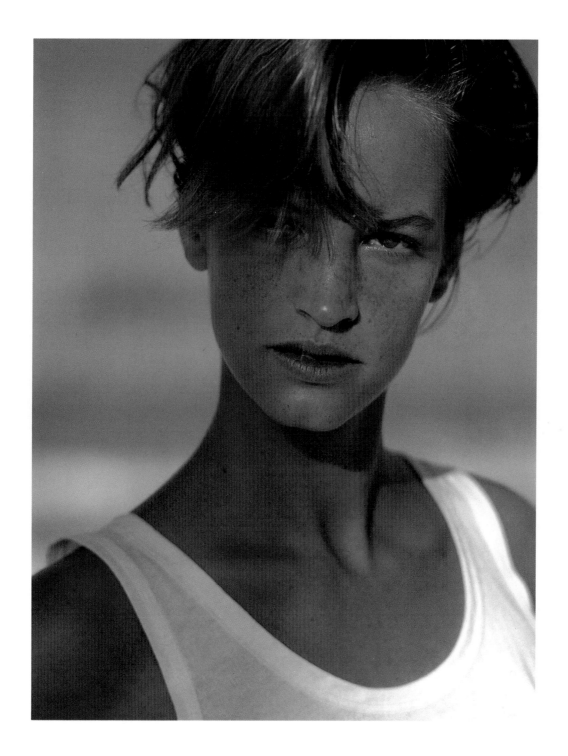

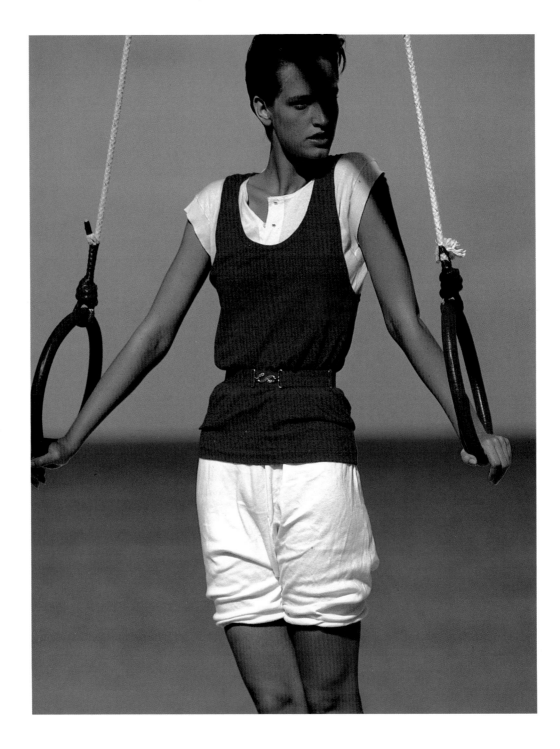

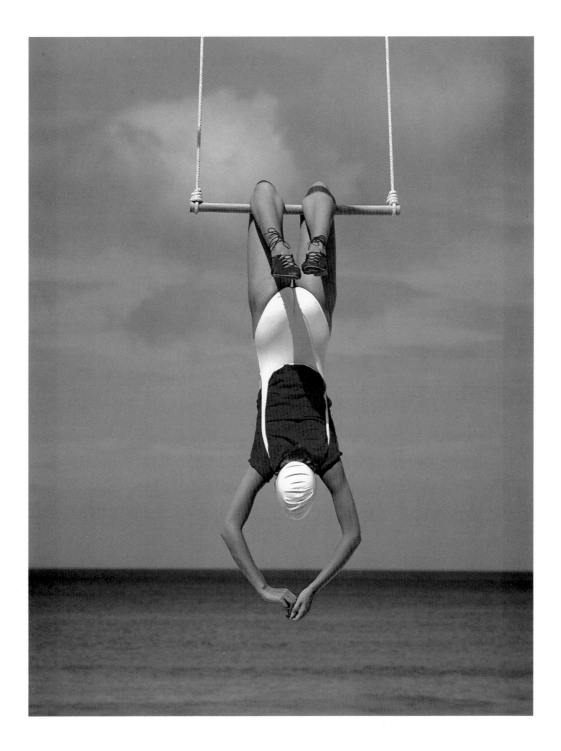

MOROCCAN REVERIE

"In this series, photographed for British *Vogue* in Morocco, I wanted to concentrate on pure, brilliant colors reminiscent of Matisse, so we looked for locations that would lend themselves to contrast and saturated color. Although some of the photos were shot on the dunes in a sandstorm, where the vibrant colors were juxtaposed against the monotoned sand, we also used a Beduin tent that only the night before had been a restaurant in which we dined. Since I liked the exotic interior of the tent, we asked its proprietor if it could be rented. The next morning we arrived at 7:00 AM and transported the tent to the desert, rebuilt it, and shot, finishing in time for the Moroccan dinner hour."

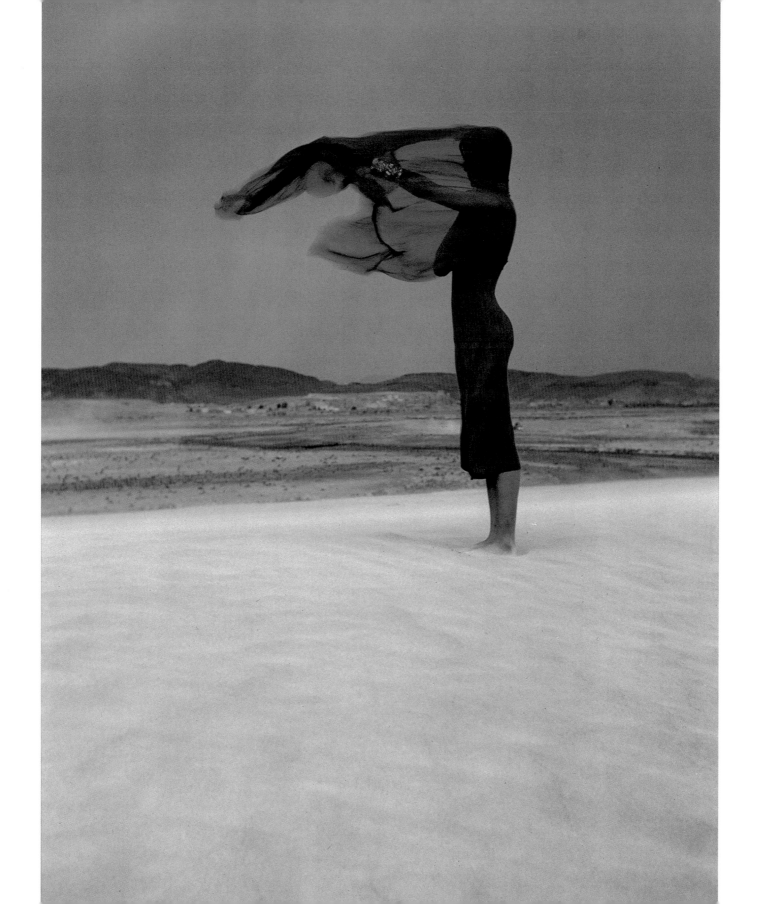

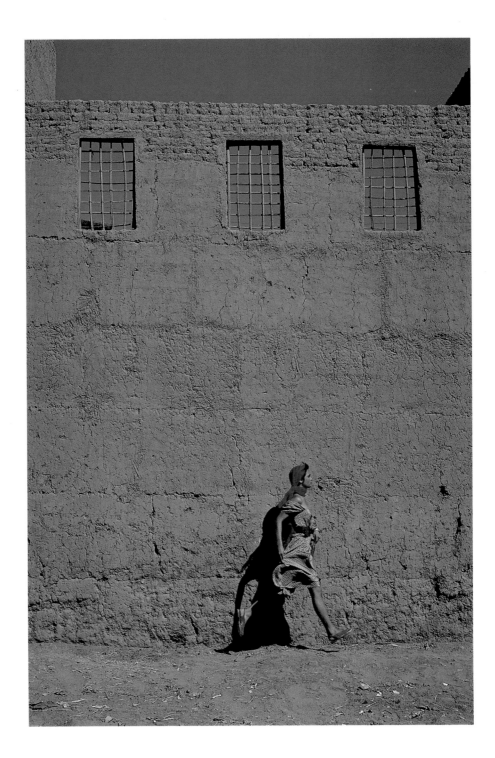

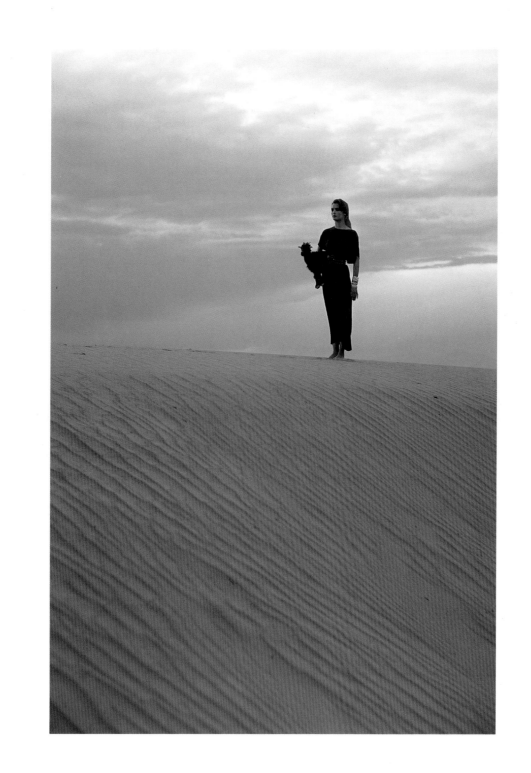

BEAUTY AND THE BEACH

"I shot this series for *Marie Claire*,
the Paris-based fashion magazine,
on a cool grey day in late January
one year. Because the weather in
the usually sunny Baja, Califor-
nia, was so somber, we decided
to use a different approach, and
shot with Polaroid Polapan 35mm
slide film (which was sent di-
rectly to the printer). Polapan
reacts very well in hazy weather,
providing a lot of contrast and an
almost infrared-like quality. We
shot all eight pages of this series
in one day, and had a lot of fun
in the process, because I asked
Cindy Crawford to pose as if she
were an actress, not a fashion
model. We created an evocative,
theatrical mood and the model
was able to express the way she
felt at the time."

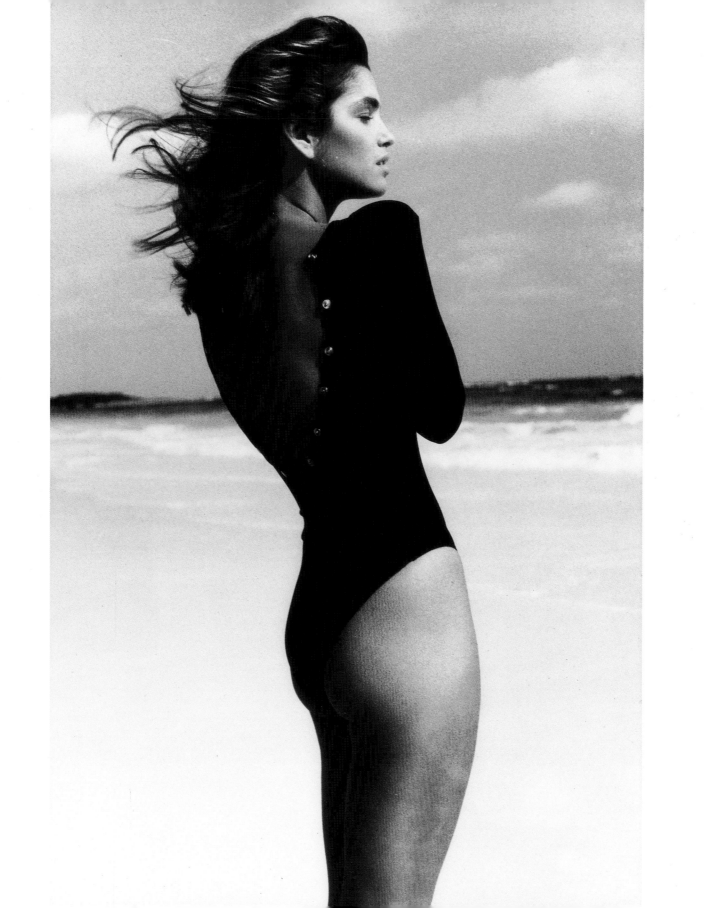

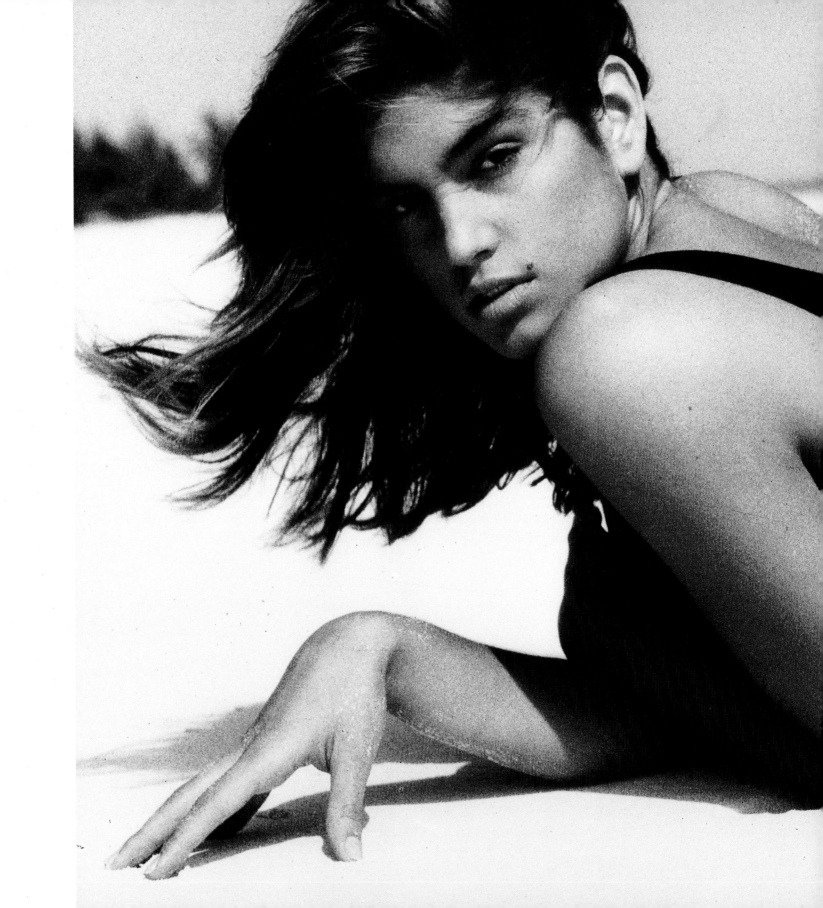

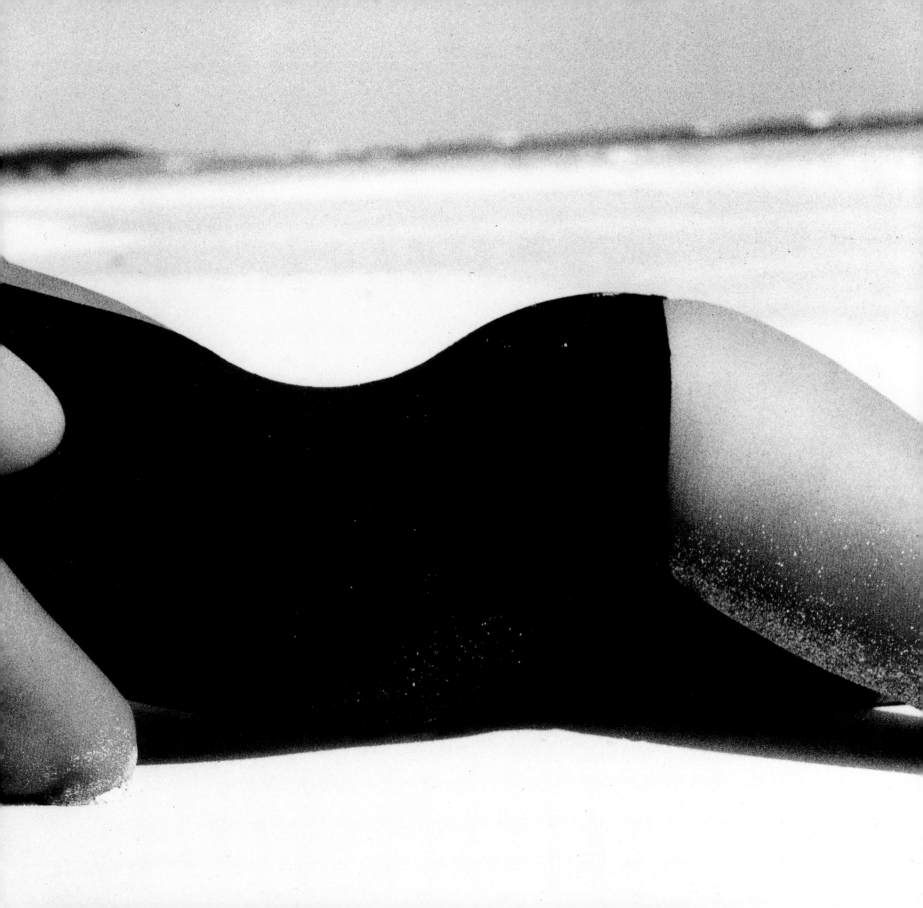

SEASCAPES

"I had been wondering for a long time what the effect would be if I were to shoot outdoors using a painted backdrop, and when British *Vogue's* Grace Coddington called me to make these photos we decided it would be a good opportunity to explore my idea. We asked a London-based painter to create a romantic seascape and ship it over to us. Some of these photos were made on the beach in East Hampton, New York, in natural outdoor light, and others were made in the studio. For the outdoor shots, model Cecilia Chancellor posed before the ten-foot-high painting. I used Polaroid Polachrome 35mm film and the seaside environment—the wind, the high grasses, and the sand—to create the soft ambience we wanted. I like the impression of uncertainty here—one can't easily discern whether the photos were shot indoors or on location."

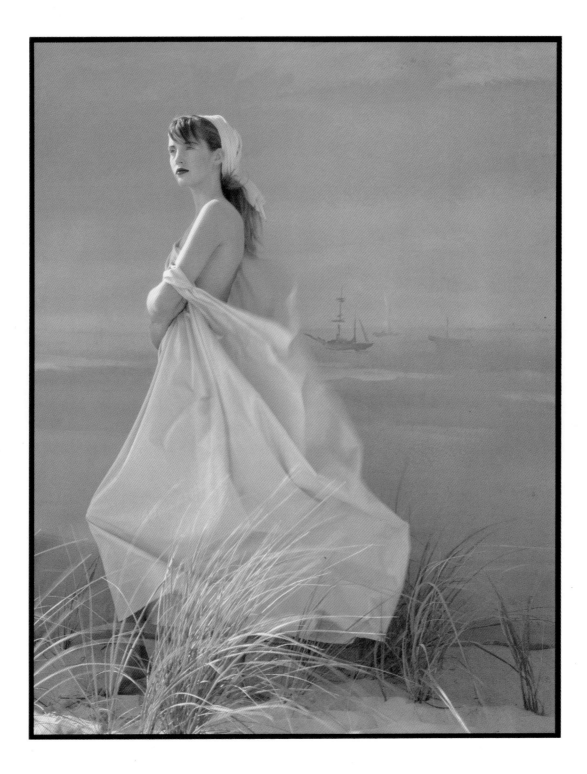

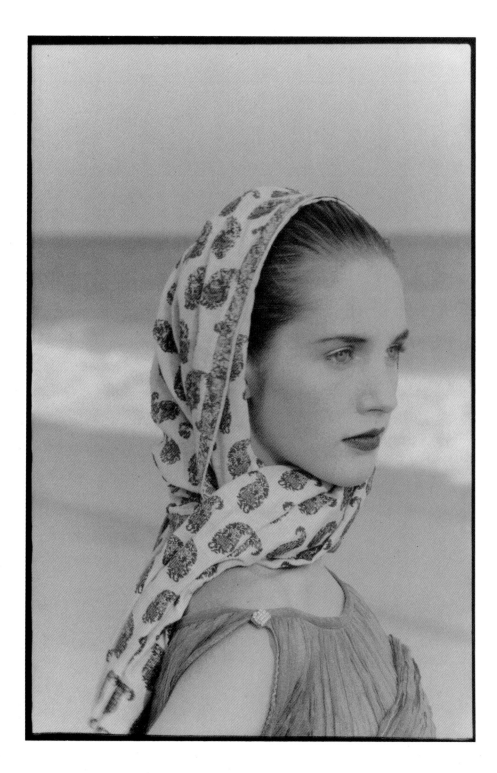

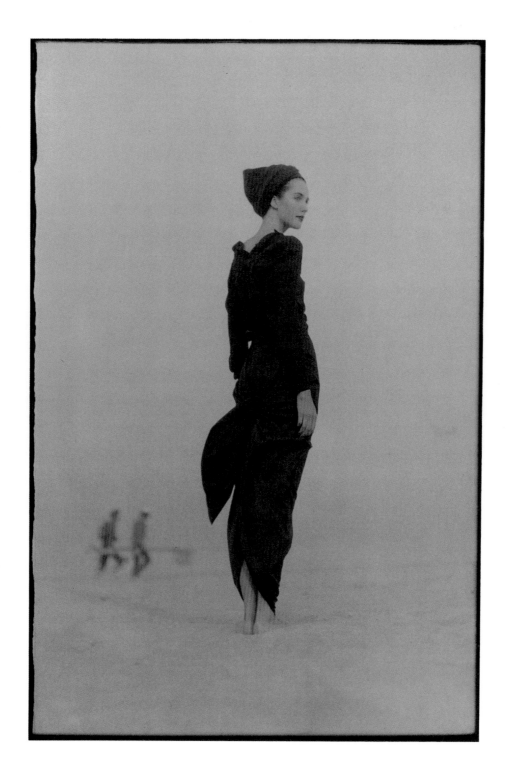

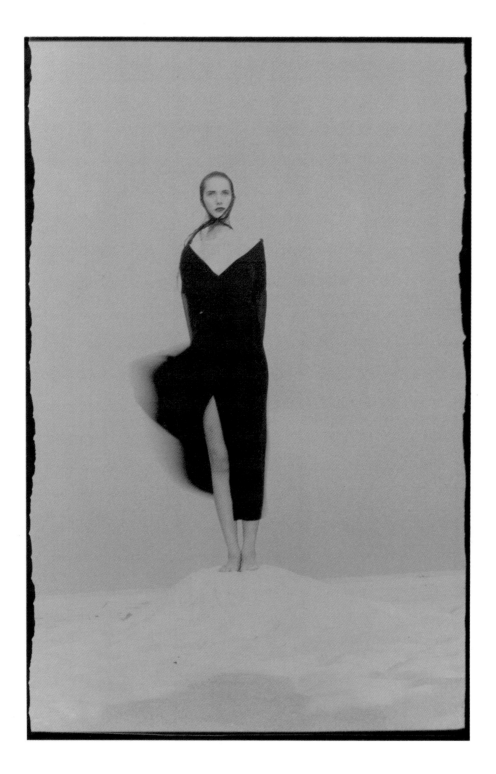

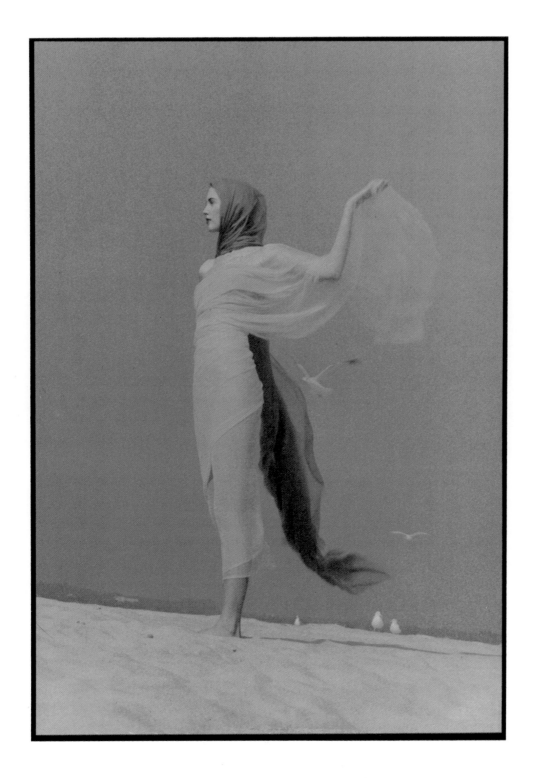

DANCERS

"This particular series required a good deal of advance preparation, because we first had to locate the dancers. We visited a number of ballet classes and dancing schools to find these women. We rented a studio, since I wanted to use a greater amount of natural daylight than my own provides, and also because it's sometimes stimulating to shoot in a different studio environment. Once again we asked a painter to provide a backdrop, and the three-day shoot was illuminated with a combination of tungsten and natural light. I asked the dancers to go through a variety of movements, and watched to find the effects that went best with the clothes and the shapes of the bodies in motion. Then we concentrated on the particular movement that best matched the fashions and the mood."

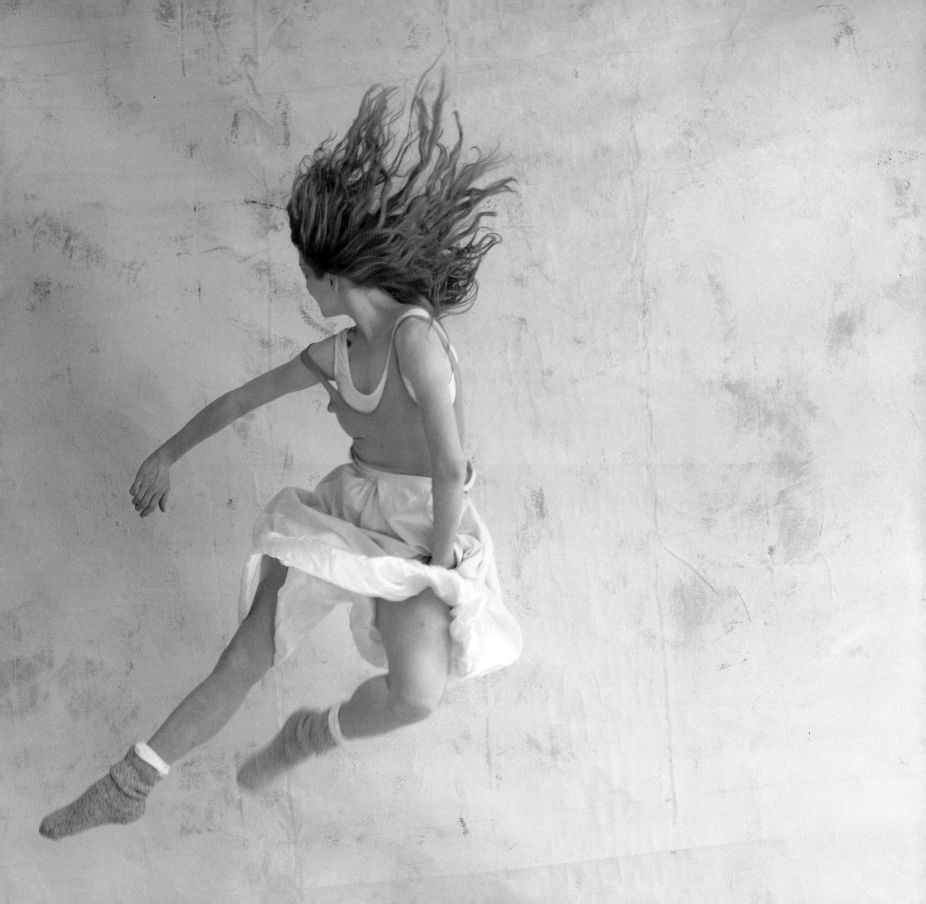

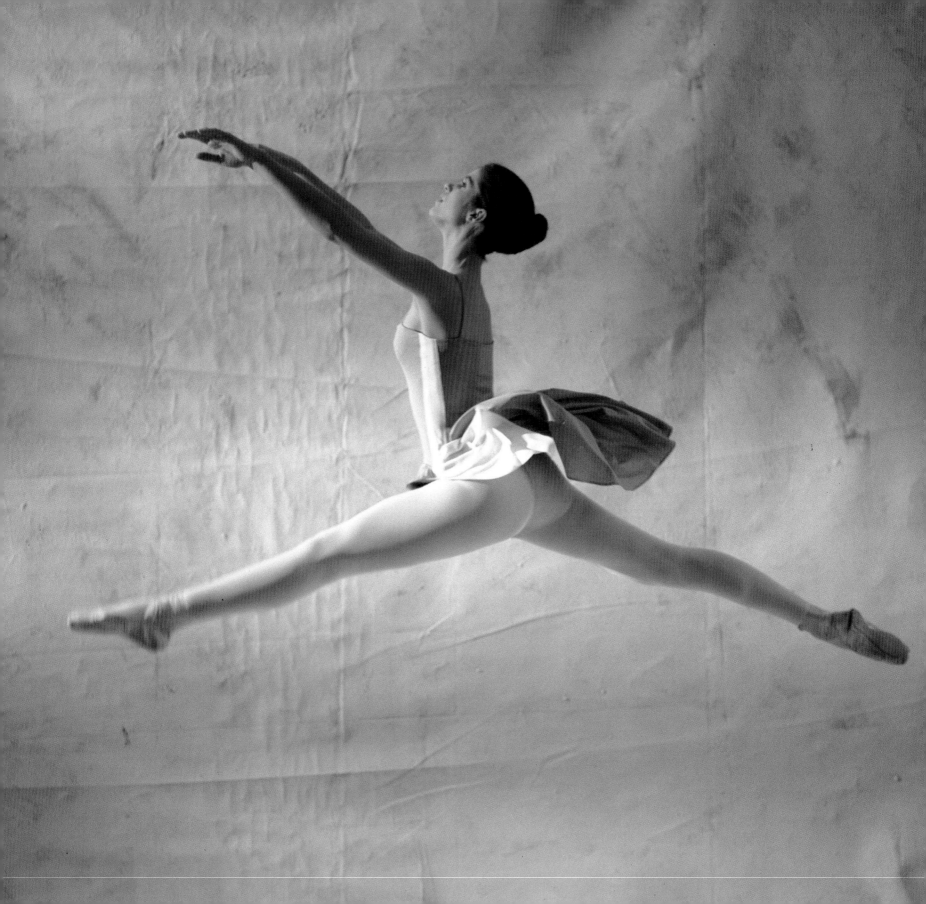

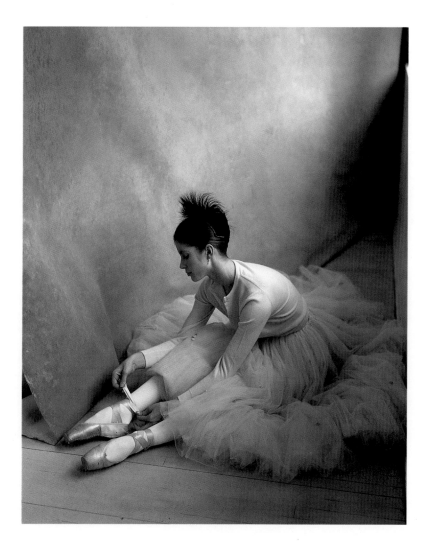

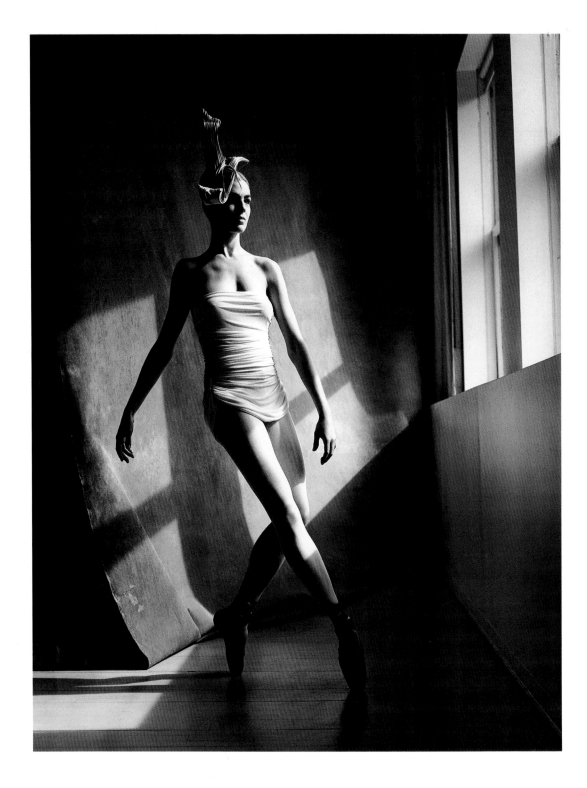

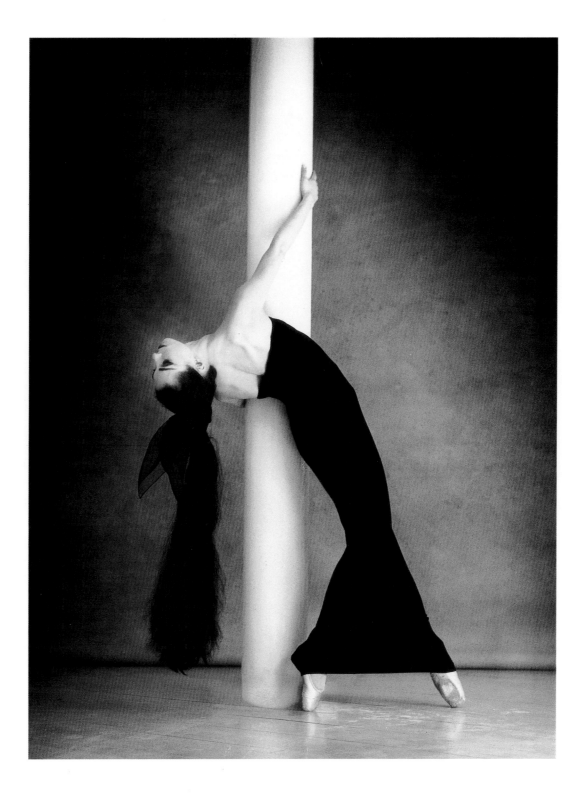

NUDES

Many fashion photographers—Patrick Demarchelier included—are fascinated with photographing nudes, perhaps because in fashion the photographer is so involved with capturing the spirited or graceful movements of the body. Just about anyone who shoots fashion regularly also has a personal collection of nudes, and many who shoot fashion incorporate the nude into their beauty and fashion work, as in Irving Penn's waist-up nudes of Paulina Porizkova in an opening essay on skin care in *Vogue,* or in Helmut Newton's sensational fashion scenes.

To Demarchelier, the nude is more like a portrait than a fashion photograph. He seeks subjects who are not necessarily models and attempts to capture the spontaneous emotion in his subject's face as well as the way light and shadow fall upon the body. "To me, the nude is particularly interesting because there are no restrictions. Without clothing, the model becomes free, and I am able to concentrate only on her, without distraction."

Demarchelier's nudes possess a classic kind of beauty, and in a sense they are studies in perfection. Unlike Penn's unconventional photographs of fleshy torsos, exhibited several years ago, or André Kertész's nude distortions, Demarchelier's subjects are goddesses of sorts—women who are purely and immaculately made. There is a tenderness in his approach, a feeling that in this most personal of his work, Demarchelier focuses on the nude as a unified subject, not on abstractions or exaggerated contrasts. Sometimes, the face plays as important a role as the rest of the figure, and he connects facial expressiveness with the movement and rhythm of form.

Certainly there is a seductiveness in Demarchelier's vision; his nudes do not exude innocence, but as in his fashion work the erotic qualities of these pictures are subtly rendered. Demarchelier has a way of watching that is nonvoyeuristic, as if the photographer had casually joined his subject in her intimate world by invitation. Made with a certain poignancy that is rarely seen in any kind of commercial work, Demarchelier's nudes are honest impressions of the way a woman's body looks. In his nudes, the figure is viewed in neither a passive nor aggressive manner, but rather, as a graceful creation that has much to say on its own about the nature of feminine beauty.

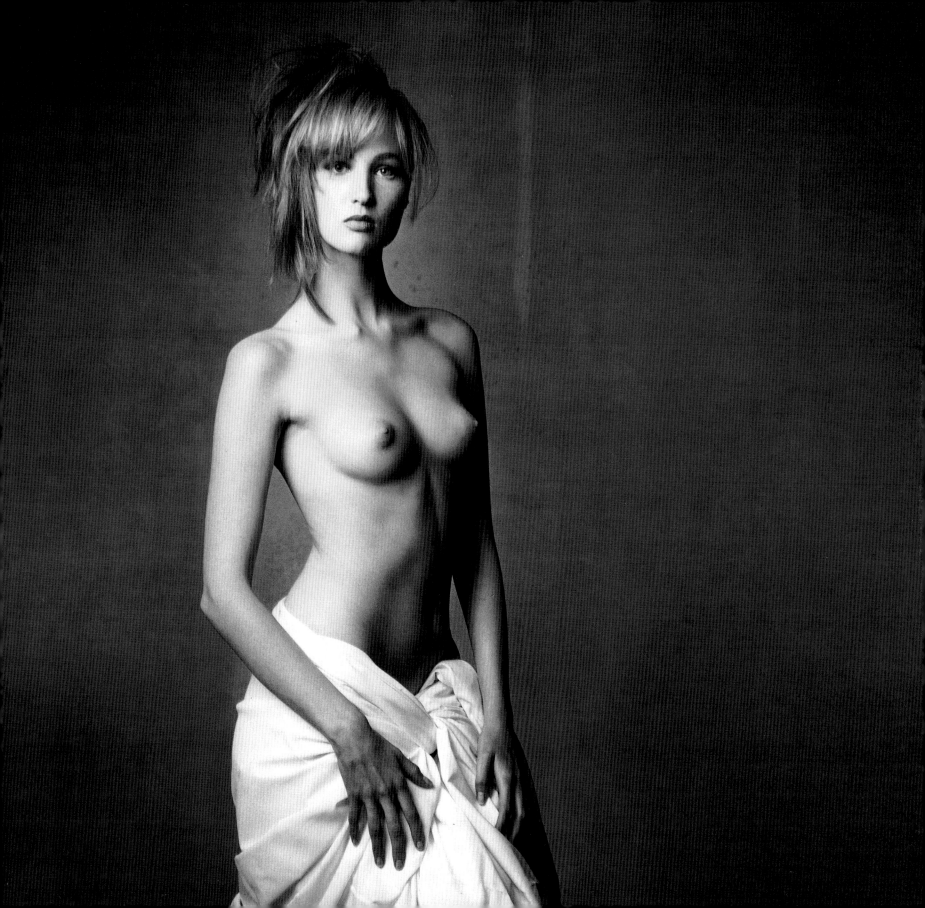

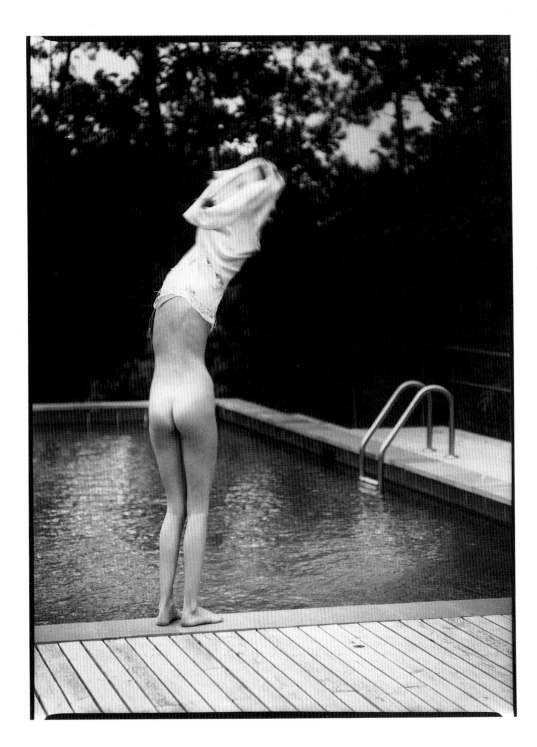

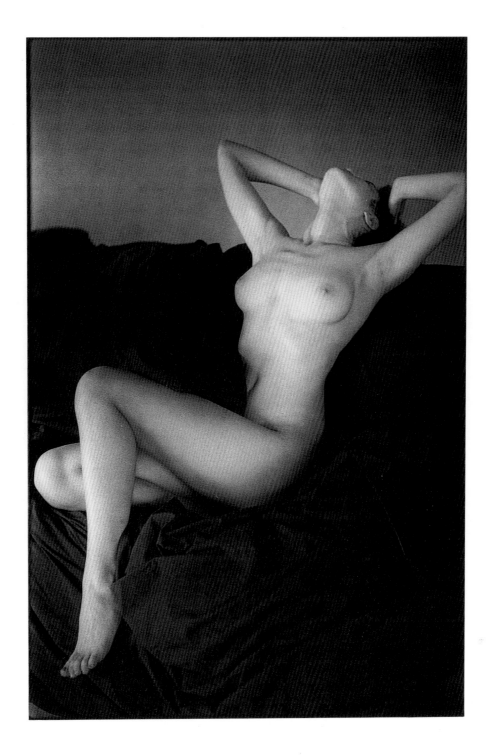

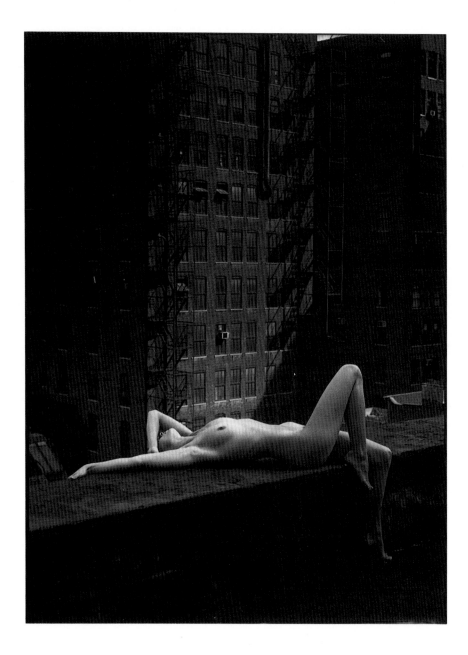

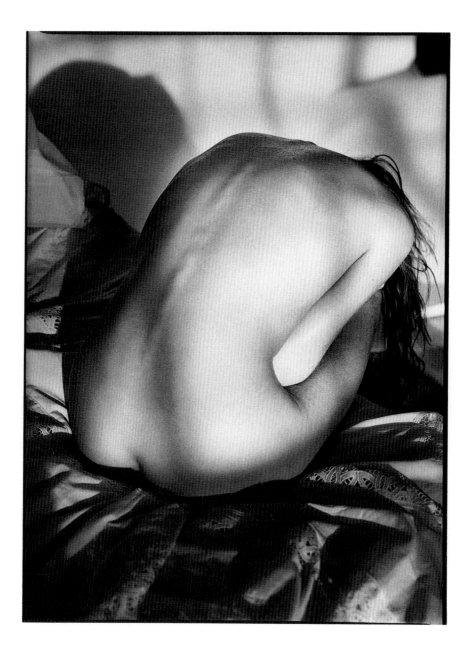

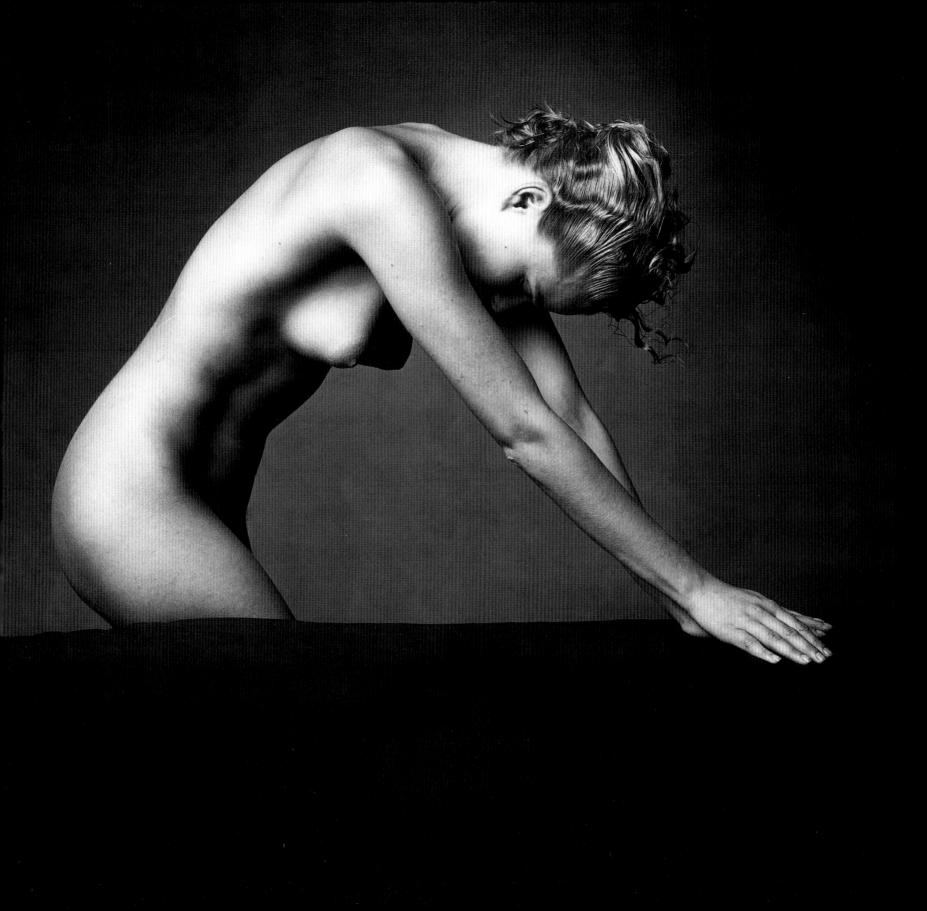

GENE HACKMAN

PORTRAITS

Some time ago, Demarchelier was asked to shoot a still-life photograph. He accepted the assignment with curiosity if not eagerness, and set up a tabletop construction, experimenting with light on boxes until late into the evening. As he worked, an unsettling sensation of intense claustrophobia overcame him; he was so bored and baffled by the parts and pieces of the motionless forms that he never again showcased an inanimate subject. "I like people," Demarchelier says, "and I like to watch faces."

Demarchelier's interest in portraiture is common among photographers who shoot fashion. Irving Penn once said that fashion is portraiture, and in the work of Richard Avedon as well it is apparent that the psyche is more intriguing than the fashionable facade behind which it hides. Not every photographer possesses the sensitivity to photographically excavate the depths of individual personality. Demarchelier has this rare ability. As a result, he has become the preferred portraitist of a long list of actors, actresses, and celebrities.

Celebrity portraiture, like fashion, is a compelling avenue of the photographic medium, not only because we are naturally inquisitive about what famous people are really like, but because we feel somehow personally rewarded when a photograph lets us in on a secret about someone we admire (or abhor). The most successful portraits reveal far more than glossy press prints or paparazzi snaps, providing surprising clues to character. Perhaps, in its best sense, a portrait is an intimate and unguarded conversation with a subject, translated by a photographer who knows how to read between the lines.

Demarchelier has uncanny ability and insight as a portraitist. His approach is not premeditated, yet it is thoughtful; he does not rely on a subject's environment or trappings to fill in the details. Instead his portraits, shot almost exclusively in black and white, have spare backgrounds and are neither highly atmospheric nor starkly

revealing. Demarchelier does not strip his subjects to expose them, nor does he focus on familiar habits or eccentricities that would only confirm what we already know. Instead, he concentrates on the moment when his subjects feel most comfortable, most at home with themselves.

In many of his portraits, eye contact is straightforward, though Demarchelier does not encourage the vacant, impersonal reaction to the camera used by many photographers seeking an objective record. He does not resort to contrived situations or unusual props, crutches used all too frequently by many celebrity photographers. The look that Demarchelier attracts toward his camera is one of intimate disclosure—as if he had just asked his subject a question or made a statement that put his sitter completely at ease. Like the models in his fashion work, his subjects appear secure and candid, almost as if they are reflecting what they see in Demarchelier himself.

Demarchelier prefers black-and-white film for portraits because he likes an array of tonal qualities and feels that color is "too obvious." By the way the photo is printed (by Cameron Stewart, Demarchelier's meticulous printer of eight years), the emotional texture of the picture can be refined. His lighting is uncomplex, but carefully individualized. In photographing fashion, Demarchelier is aware that different colors and fabrics require more or less light to bring out detail. Similarly, he determines each portrait setup based on the angles and contours of the face. Demarchelier visibly cringes at the mention of lighting formulas; he finds any routine irksome.

"Demarchelier's is the less-is-more approach to picture-making," observes Jim Larson, associate editor of photography at *Playboy*, which has run several portfolios of Demarchelier's celebrity portraiture. Larson was attracted to the photographer's "what-you-see-is-what-you-get" attitude, which may indeed be the most difficult kind of portrait to effectively make. As Larson points out, Demarchelier does not fabricate a response from his subjects by using distractions, backgrounds, props, or wardrobe.

One might think that celebrities, who are accustomed to the glare of public observation, would be comfortable in a portrait situation, but many may be more guarded because they feel they must maintain a glamorous image. Demarchelier understands that even the most publicly visible subject may feel trepidation when entering a portrait session. "An actor knows that people will see his film and go home," he says. "But a portrait can be more frightening because it is permanent; people may scrutinize the photo again and again."

Demarchelier asserts that the mystical belief that the act of portraiture steals the soul

may in some ways be very true, so he tries to take his subjects by surprise—to capture an expression almost before his sitter realizes the photographer is ready. "The idea is to steal something before the subject has a chance to look the way he wants, before he has an opportunity to take an artificial pose."

Demarchelier thinks there is a great deal of psychology involved in making a portrait. In his sessions, which may take only an hour or two (during which he shoots ten to twelve rolls of film), he concentrates on establishing an atmosphere of trust. He doesn't rely on mood music or champagne, but simply projects his own humanity. "Making another person relaxed has a lot to do with yourself," he says. "If a photographer is very nervous or arrogant, the subject will respond to that." It is nearly impossible to feel self-conscious or defensive around a photographer who wears wrinkled shirts and a charming grin, and who often whispers, "Ah, c'est belle."

Demarchelier has made many portraits of actress Mariel Hemingway, who says she is most content when he is on the other side of the camera. "Patrick's own relaxed attitude and look make me feel relaxed," she says. "I always have the sense that he is sincere." Often in celebrity portraiture, she adds, the photographer is the "star," and arrives with a busy entourage to match his inflated ego. "It's an ordeal to be around photographers who work that way," says Hemingway. "Patrick is not trying to be more of a personality than the individual whom he is photographing." His style of working also fits well with the hectic schedules that many celebrities follow. "He doesn't take a lot of time or overdo things."

When Demarchelier meets his subjects he often looks first at their hands—"the most important indicator of a person's way of life, because hands are the key to expression," he says. Frequently, he incorporates these natural gestures in his photographs, as in the image of Warren Beatty, a closely framed shot in which the strength of the actor's hands affirms his bold facial features. Beatty, in fact, posed for Demarchelier's first celebrity portrait, and since that initial sitting the actor has often referred his colleagues to the Frenchman when a portrait is needed.

Demarchelier uses a Mamiyaflex, Pentax, or Hasselblad camera with a 100mm or 120mm lens, as he generally likes to shoot at a close distance to enhance the intimacy of the sessions. "Some people are easy and full of life," he says. "They express themselves on the outside. Others may be bright and clever, but they keep everything inside—the face is like a mask. If they are cold on the outside, I try to warm them up."

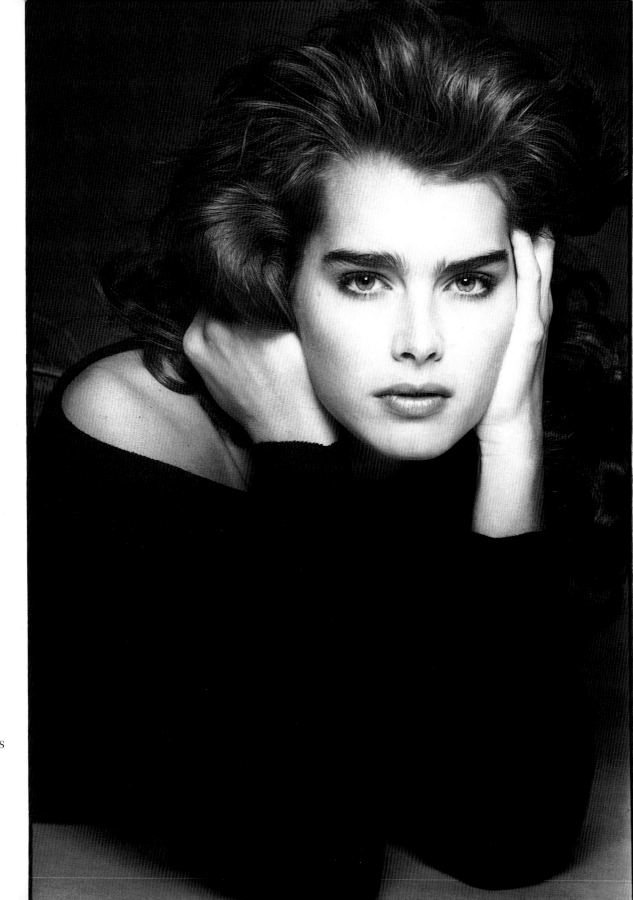

BROOKE SHIELDS

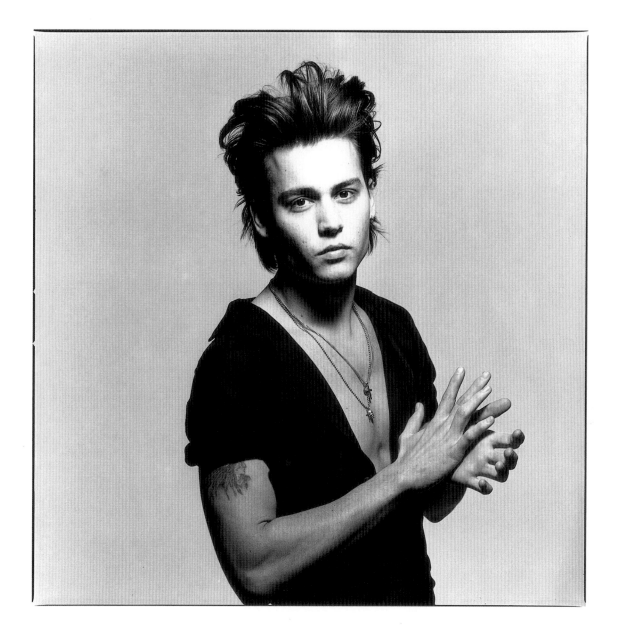

JOHNNY DEPP

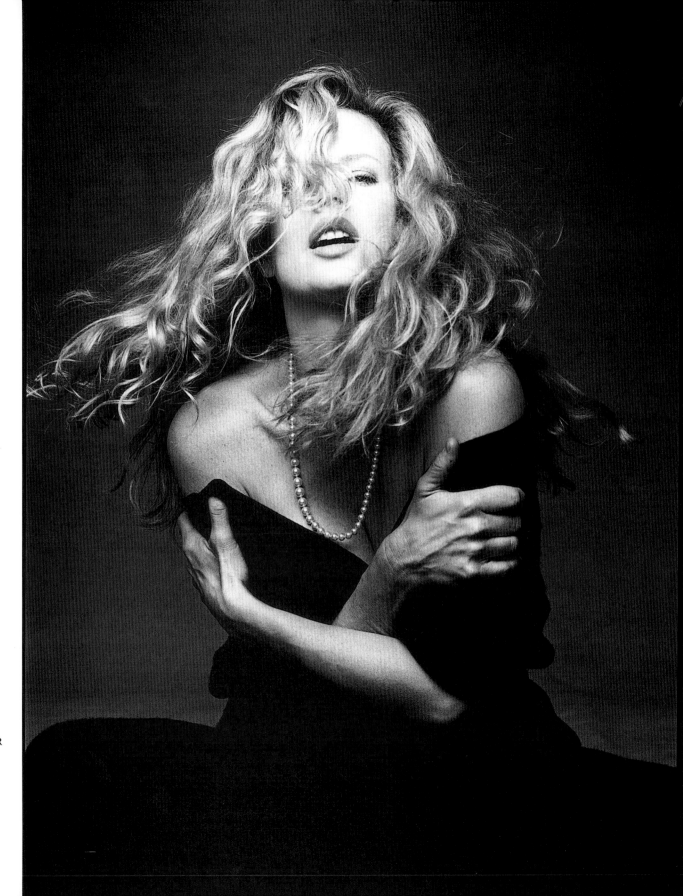

KIM BASINGER

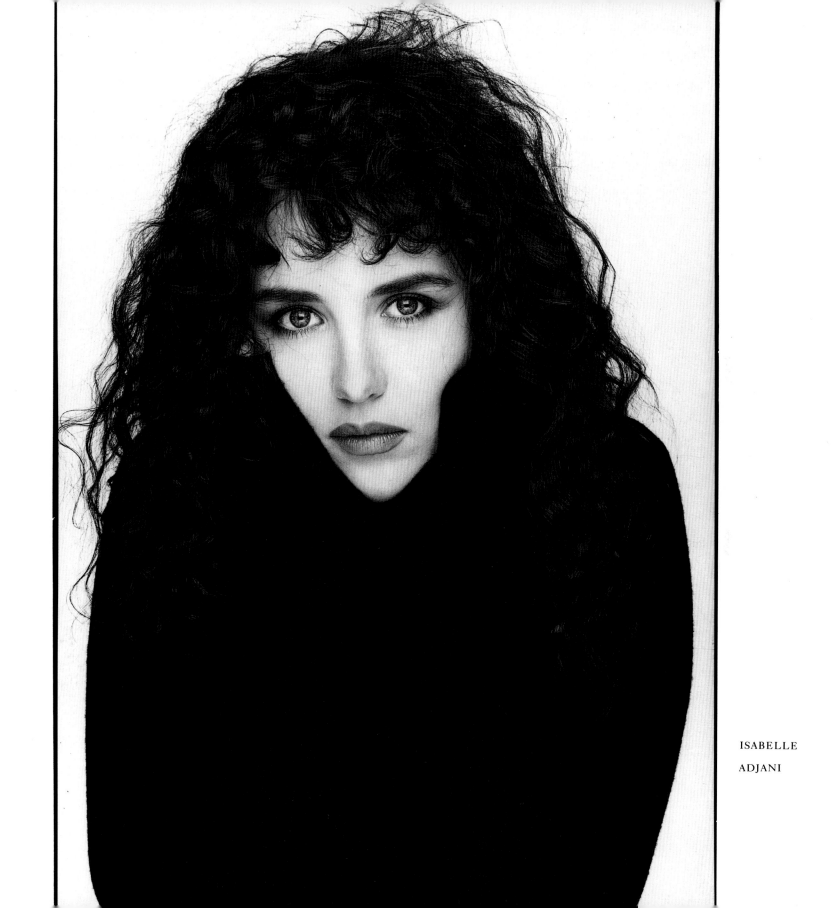

ISABELLE
ADJANI

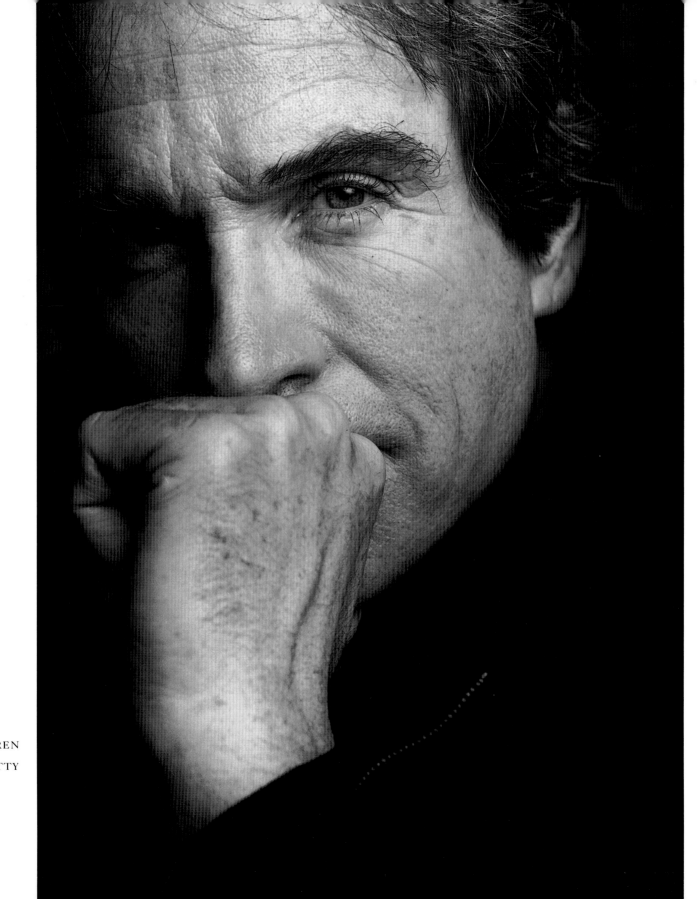

WARREN
BEATTY

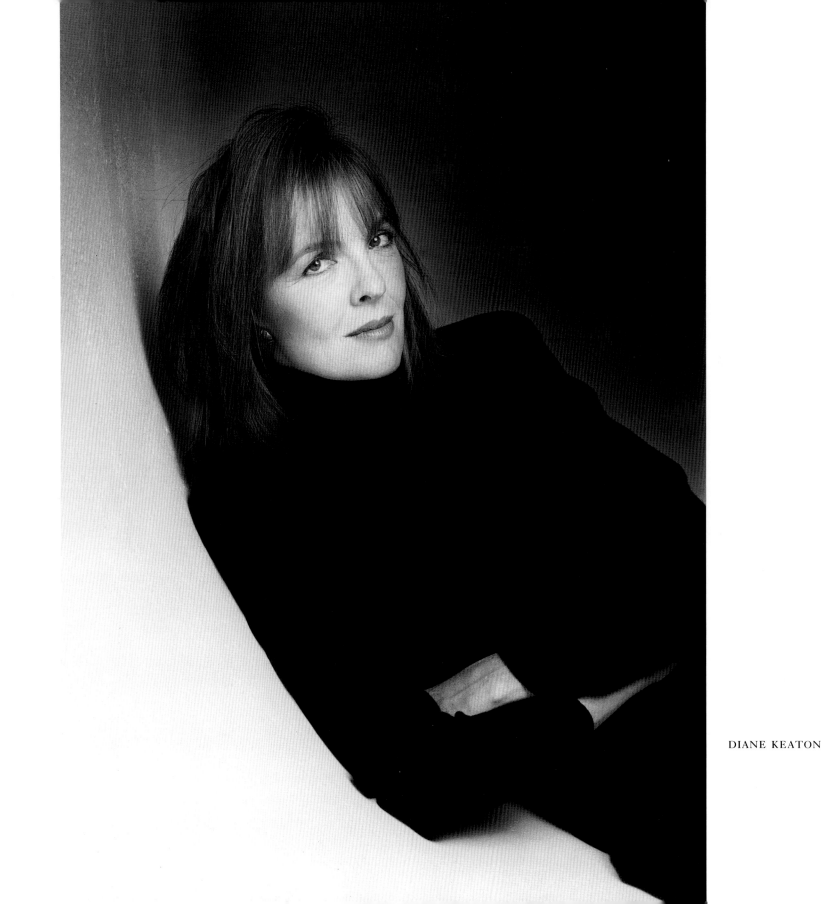

DIANE KEATON

BILLY JOEL

RICHARD ATTENBOROUGH WITH JANET JONES

MICHAEL DOUGLAS

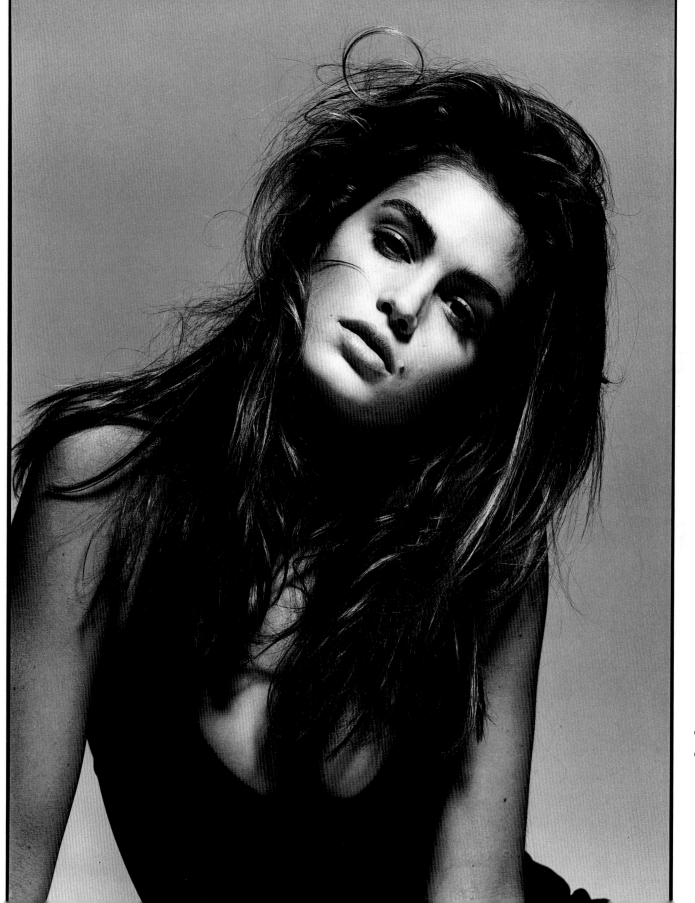

CINDY

CRAWFORD

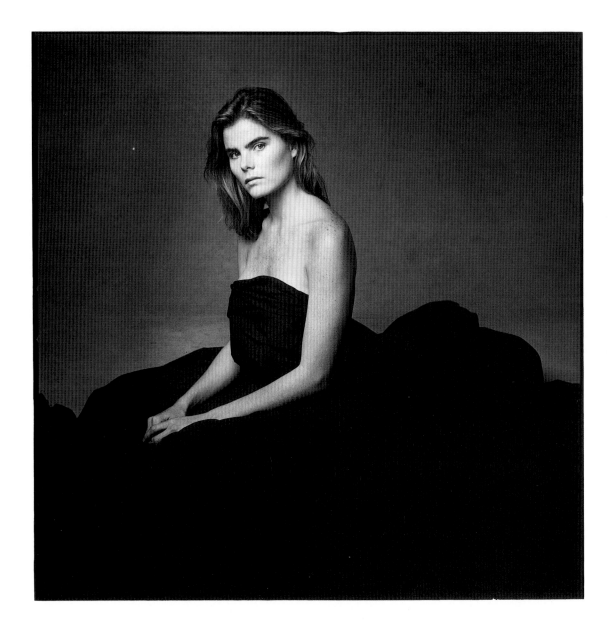

MARIEL HEMINGWAY

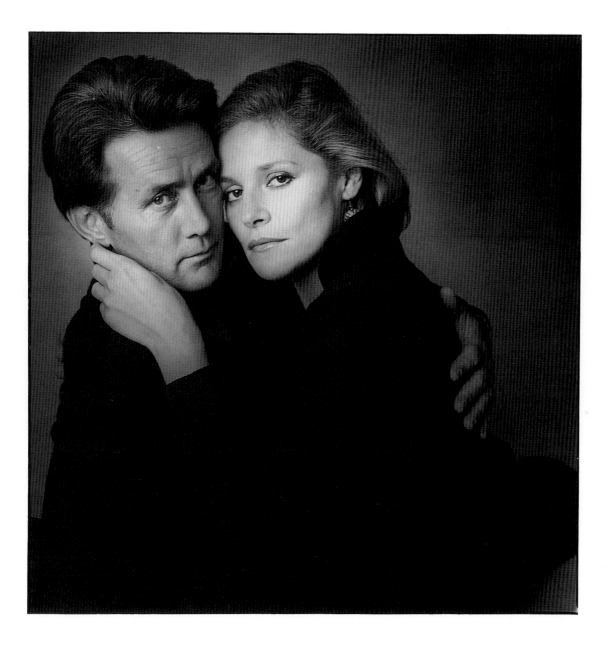

MARTIN SHEEN AND HELEN SHAVER

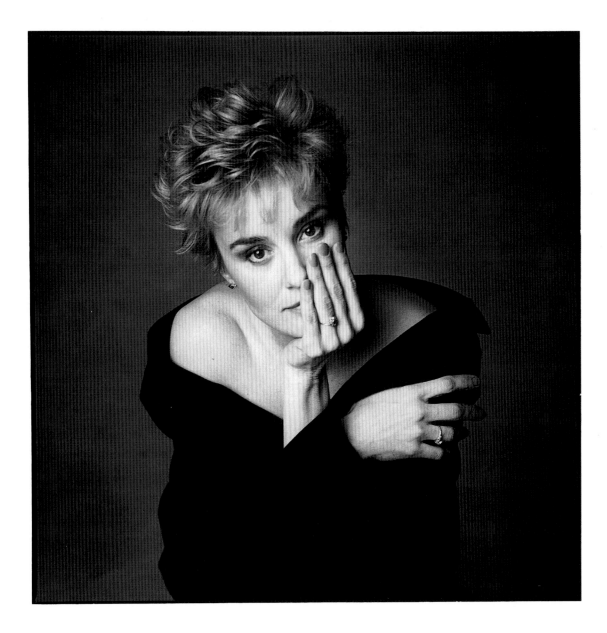

JESSICA LANGE

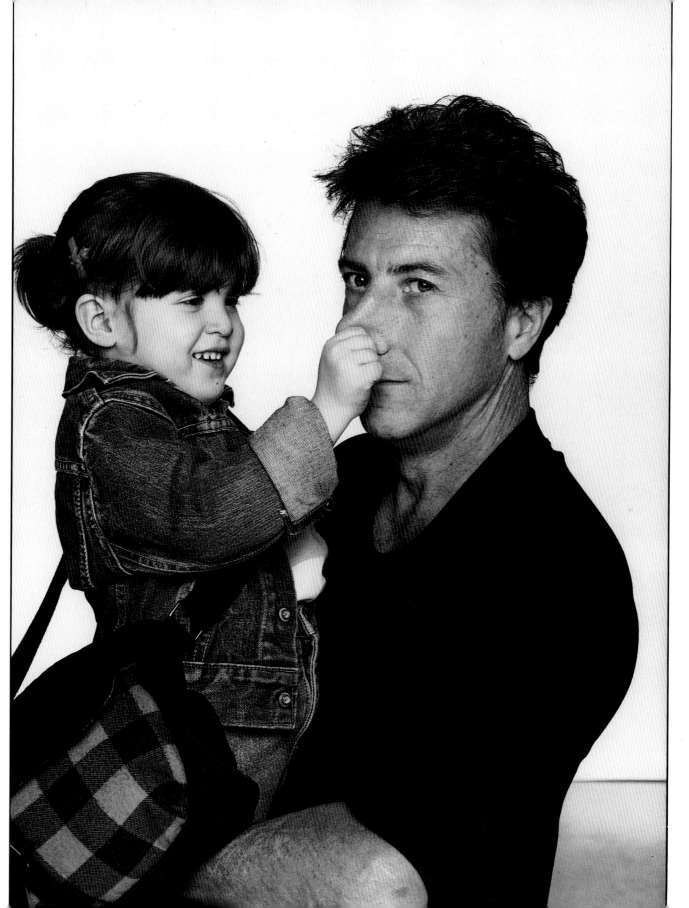

DUSTIN
HOFFMAN
WITH HIS
DAUGHTER,
REBECCA

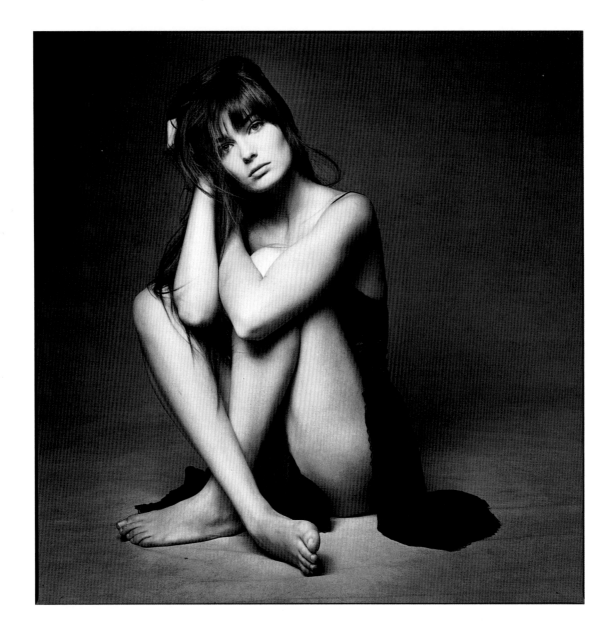

PAULINA PORIZKOVA

ISABELLA ROSSELLINI AND HER DAUGHTER, ELETTRA

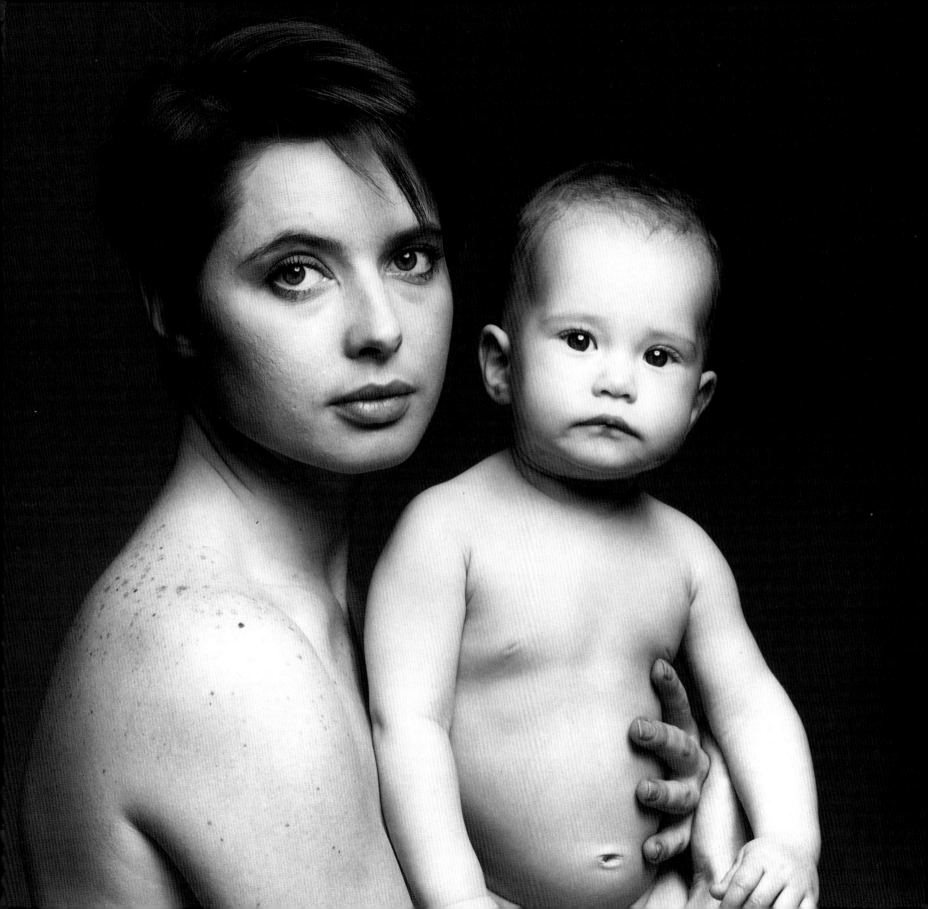

CHRISTIE BRINKLEY, BILLY JOEL,
AND THEIR DAUGHTER, ALEXA RAY

PHOTOGRAPHER'S ACKNOWLEDGMENTS

Special thanks to Condé Nast Publications and American *Vogue*, British *Vogue*, French *Vogue*, and German *Vogue*, as well as to *Cosmopolitan*, *Elle*, *Glamour*, *Harper's Bazaar*, *Life*, *Mademoiselle*, *Marie Claire*, *Newsweek*, *Photo*, and *Rolling Stone*. Also to those advertising clients, art directors, celebrities, editors, hairstylists, make-up artists, models and subjects, set stylists, and others who made these photographs happen. *Models:* Bonnie Berman, Cecilia Chancellor, Clotilde, Cindy Crawford, Michele Eabry, Estelle, Linda Evangelista, Jerry Hall, Lara Harris, Marie Lindfors, Naomi, Gail O'Neil, Yasmine Parvenah, Tatjana Patitz, Paulina Porizkova, Elisabetta Ramella, Lenna Robinson, Stephanie Saland, Joan Severence, Talisa Soto, Sarah Stead, Christie Turlington. *Hair:* Bruno Decugis, Bruno Dessange, Odile Gilbert, Maury Hobson, Sally Herschberger, Julien, Didier Malige, Jean Marc Maniatis, Sam McKnight, Oribe. *Fashion Editors:* Lisa Atkins, Martha Baker, Michaela Bardini, Betty Bertrand, Carlyne Cerf, Lucinda Chambers, Grace Coddington, Anna Harvey, Jade Hobson, Lizette Kattan, Joe McKenna, Walter Rospert, Franca Sozzani, Elizabeth Tilberis, Anna Wintur. *Celebrities:* Isabelle Adjani, Muhammad Ali, Richard Attenborough, Ellen Barkin, Kim Basinger, Warren Beatty, Christie Brinkley and her daughter, Alexa-Ray, Kevin Costner, Brian De Palma, Johnny Depp, Michael Douglas, Gene Hackman, Mariel Hemingway, Dustin Hoffman and his daughter, Rebecca, Billy Joel, Janet Jones, Diane Keaton, Jessica Lange, Isabella Rossellini and her daughter, Elettra, Helen Shaver, Martin Sheen, Brooke Shields, Sean Young. *Make-up:* Carlo Alberto, Bobbi Brown, Fran Cooper, Mary Greenwell, Sophie Levy, Bonnie Maller, Joey Mills, Moira Mulholland, Francois Nars, Phophie, Mariella Smith-Masters. *Advertising:* Buffy Birrittella, Sandy Carleson, Martha Everds, Dick Huebner, John Louise, Jeff Rafalef, Murray Salit, Sam Shaheed, Rochelle Udell, Linda Vos, CRK, McNamara, Clapp, and Klein, Wells, Rich, Greene. *Also:* Fabian Baron, Leslee Dart, Lillian Davies, John Hind, Jacque Nointel, William Rayner, Roger Schoening, Peggy Siegal, Lois Smith, Bernard Speiser, Tony Verga.

Special thanks to Pierre Houles

AUTHOR'S ACKNOWLEDGMENTS

The author is particularly grateful to Patrick Demarchelier, whose wisdom in words and pictures guided the creation of my text.

Those who play vital roles in the worlds of fashion, glamour, advertising, and editorial photography move with alarming speed. For hesitating long enough to offer the valuable observations included in this book, the author would especially like to thank Jim Abel, Martha Baker, Bryan Bantry, Buffy Birrittella, Sandy Carlson, Cecilia Chancellor, Grace Coddington, Gerald Dearing, Tony DeVino, Martha Everds, Mary Greenwell, Mariel Hemingway, John Hind, Dick Huebner, Jim Larsen, Alexander Lieberman, John Louise, Didier Malige, David Markus, Polly Mellen, Patty O'Brien, Paulina Porizkova, Jeff Rafalef, Murray Salit, Mary Shanahan, Teri Shields, Cameron Stewart, Wayne Takenaka, Elizabeth Tilberis, Rochelle Udell, Miaja Veide, Linda Vos, and Anna Wintour.

Special thanks to my husband, Mitchell Kriegler, and son Aaron, and to stalwart advisors Edward Kusyk and Richard Hein.

For his encouragement and insight, I'd like to thank Sean Callahan, founding editor of *American Photographer*.

Thanks also to Henry Horenstein of Pond Press, Janet Bush of Bulfinch Press, and designer Lisa DeFrancis.

CREDITS/MODELS

p. I Christie Turlington, p. II Paulina Porizkova, p. VI Paulina Porizkova, p. 8 Estelle, pp. 10–11 Estelle, pp. 14–16 Gail O'Neil, p. 21 Christie Turlington, pp. 22–23 Michele Eabry, pp. 26–27 Christie Turlington, pp. 29–31 Christie Turlington, pp. 35–37 Marie Lindfors, p. 41 Elisabetta Ramella, pp. 42–43 Lara Harris, pp. 47–49 Tatjana Patitz, p. 50 Paulina Porizkova, p. 63 Clotilde, pp. 64–65 Talisa Soto, p. 68 Cecilia Chancellor, p. 71 Linda Evangelista, pp. 72–73 Gail O'Neil, p. 74 Yasmine Parvenah, p. 75 Naomi, pp. 77–81 Bonnie Berman, pp. 83–85 Talisa Soto, pp. 87–89 Cindy Crawford, pp. 91–95 Cecilia Chancellor.